Sketching
with

ALWYN
CRAWSHAW

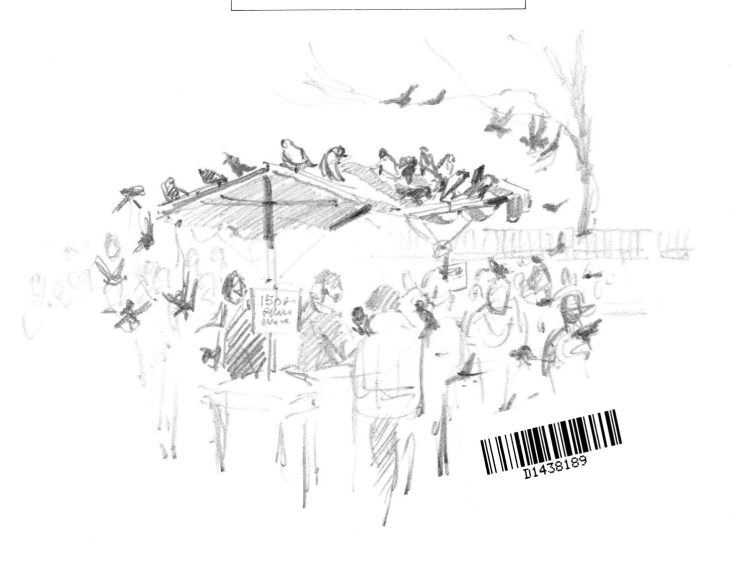

First published in 1988
by William Collins Sons & Co., Ltd
London · Glasgow · Sydney
Auckland · Toronto · Johannesburg

**British Library Cataloguing in Publication
Data**
Crawshaw, Alwyn
 Alwyn Crawshaw—artist's sketchbook
 1. Drawing
 I. Title
 741.2 NC710

 ISBN 0-00-412256-9

Designed by Caroline Hill
Filmset by V & M Graphics Ltd,
Aylesbury, Bucks

Originated, printed and
bound in Hong Kong by
Wing King Tong Co Ltd

**The sketch on the front cover was done on
Bockingford paper, whereas the similar
sketch on page 42 was done on cartridge
paper.**

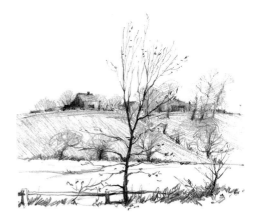

PORTRAIT OF THE ARTIST

Alwyn Crawshaw was born in Mirfield in Yorkshire in 1934, and now lives in Devon with his family. He attended the Hastings School of Art where he studied painting in different mediums. Over the years he has become a successful painter, author and lecturer, and works in oil, watercolour, pastel and acrylic. Crawshaw paints realistic subjects, and is perhaps best known for his scenes of English landscapes.

Alwyn Crawshaw is a Fellow of the Royal Society of Arts, a member of the Society of Equestrian Artists and the British Watercolour Society. His paintings are in private collections in Britain and are sold in art galleries in the UK, France, Germany, North and South America, Australia and Scandinavia. He has also held numerous one-man shows at Harrods, London's prestigious department store.

Alwyn Crawshaw has written eight books in Collins' *Learn to Paint* series and an autobiography of his painting career, entitled *The Artist at Work*. He has been a guest on radio phone-in programmes talking directly to the public about their painting problems and has appeared on television several times. He also regularly gives painting demonstrations and lectures to art groups and societies throughout Britain.

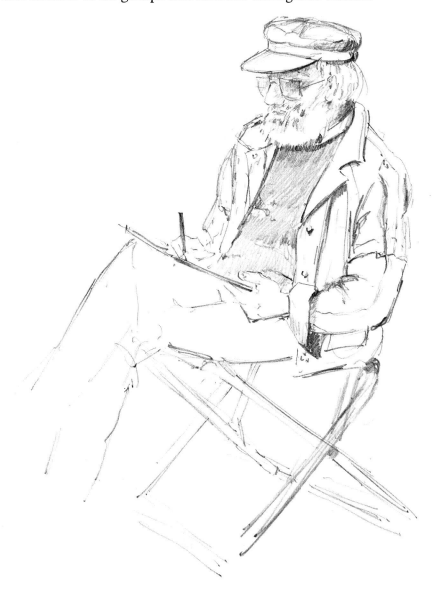

Alwyn by June Crawshaw

I have been painting all my life and yet I am still fascinated by watching other artists at work. Whether they be professional or amateur, I always have to stand and watch. Perhaps one reason for this is that painters regard each other as kindred spirits. If you see a group of people watching an artist painting, before long you hear comments like, 'Doesn't that look real?' or 'I wish I could do that,' from the onlookers. It doesn't matter whether you paint better, or worse, than the artist at work; you still get a tremendous feeling of being a fellow-painter and that is what's important.

To be a professional artist working for a living, or an amateur artist painting as a hobby, means that you are a creative person by nature, always searching for inspiration and ways to extend your talent. So when we watch a fellow artist working, we are looking not only at the finished result, but seeing how it was achieved and trying to pick up hints and tips about technique.

It is also important for leisure painters to discover that some of the methods they themselves use are those used by professional painters. When I demonstrate to students and I use the same techniques they use, their reactions can be quite overwhelming. Working away at home they have devised their own methods of dealing with the practical and creative problems of painting. Therefore, when they see a more experienced artist doing something in the way they do, they are encouraged and feel a part of a select group rather than outsiders fumbling along as best they can. I have seen a student's confidence boosted dramatically by this, and confidence in painting always leads to better and happier painting. Through local art societies, and by going on painting courses and painting holidays, a student can see other artists at work, both the professional tutor and also the rest of the class, often with varying degrees of painting ability. It is very helpful and stimulating for amateurs to be able to do this from time to time.

Sketchbooks are very personal to an artist

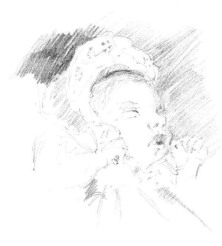

However, there seems to be one part of a professional painter's work that is kept secret and not often seen by the general public, and that is the sketchbook. Speaking for myself, my sketchbook is a very personal thing and this applies to most artists I know. In fact, some artists would not share their sketches with other people, and in a way I can understand that. It is rather like showing someone the inside of a new house before it is decorated, with its bare wood, plaster walls and concrete floors. Or, even showing the plans of the house before it is built. It is the end result that you prefer to show people – the house with your character reflected in the decor and furnishings.

Personally, I don't mind people seeing my sketchbooks; in fact, I believe students can learn a lot from them. And so it is no surprise that I started to think about publishing a sketchbook. Two very important incidents helped me to formulate this sketchbook idea. A few years ago I bought printed reproductions of two of John Constable's small sketchbooks. These sketchbooks were perfect facsimiles of ones that he had used during a two-year period of his life. The quality of the reproduction was very high and, when you looked through the pages,

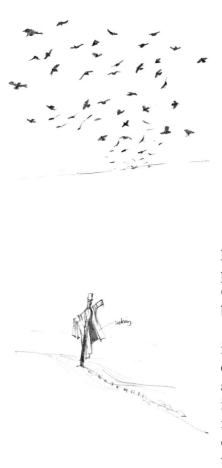

they really could have been Constable's original pencil sketches you were looking at. Some of his famous large paintings started as small sketches in these sketchbooks. Apart from giving me tremendous inspiration, I found that here was one of the greatest landscape artists, occasionally opening his sketchbook the wrong way round and doing a sketch upside down! Haven't we all done that at some time or another? – and isn't it nice to know that one of the great masters was also human!

Another reason for wanting to publish one of my sketchbooks is because I always find when I have a group of students with me that if I suggest showing them my sketchbook, they gather round excitedly like bees round a honey-pot. They feel that they are privileged to be able to look into the innermost secrets of my painting life. After all, a professional artist's sketchbook is often for 'his eyes only'. Perhaps even Constable might not have given permission for his sketchbooks to have been published if he had still been alive, but I like to think he would!

The 'sketchbook' which starts on page 17 is not intended as an instructional 'how to sketch' book, but simply an accurate reproduction of a selection of sketches I have done over the past couple of years. The aim is to show how a professional artist works and to stimulate and inspire other would-be artists. I would like to hope, too, that for any reader who is a non-painter this book might stir some long-forgotten childhood painting ambitions that could be rekindled after thumbing through these pages.

The sketches in this book are not necessarily the 'best ones'; they have been chosen to give a good cross-section of my sketching work during this period. Nearly all the pages are reproduced actual size, since most sketchbooks are this format, but as I do sometimes use a larger sketchbook a few of the pages have been reduced to fit.

The colour section in this book appears where it does simply because of the restrictions of printing and binding processes, not because I suddenly saw everything in colour and not black and white for a change! The watercolour sketches were done in a sketchbook containing either Cartridge Drawing paper 60lb, or Whatman Watercolour paper 200lb NOT, but occasionally also Bockingford Watercolour paper 200lb. The colours I have used are French Ultramarine, Crimson Alizarin, Yellow Ochre, Cadmium Yellow Pale, Hooker's Green No.1, Cadmium Red, with a Number 6 sable brush and a Number 2 Dalon Rigger brush.

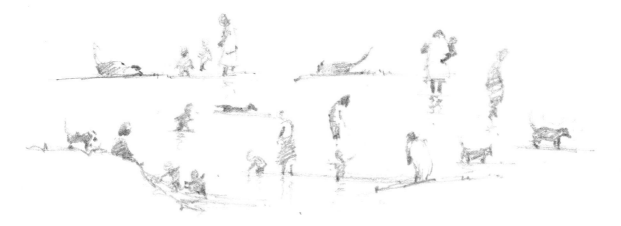

A sketchbook is a source of reference

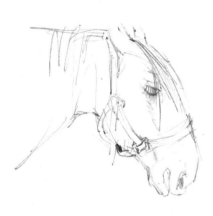

I think I should explain how important sketching is in my life. I suppose you could say that a sketchbook is a professional artist's visual store of experiences. A sketch starts all paintings, even if it is only seen in the mind's eye – it is the plan, the way ahead. If you work out of doors and you can't take your painting gear along with you, then a sketch has to be almost as convincing as a section of landscape brought into your home. Naturally, from a first sketch you improvise and use your imagination to create your picture, but the starting-point and constant source of reference is the sketch.

My preferred medium for sketching is a pencil, but I also use watercolour, and sometimes oil. Usually I work outdoors in the countryside, by a river estuary or harbour. The sheer joy and satisfaction I get from sketching is indescribable – perhaps it is the fact that I am alone with nature, and I can feel the warmth of the sun, the dampness of an autumn afternoon, or the smell of decaying leaves. When I am sitting sketching and there is quietness all around I feel privileged to hear and see the wild life going about its daily work. Even now after sketching for years, I get a feeling of elation and satisfaction when I have finished a sketch, knowing that I have recreated the scene in front of me on paper, and that I have it to refer to and remind me of that moment for the rest of my life.

Often, when I have finished a sketch, I just sit and think how fortunate I am to be able to work so close to nature, doing what I love to do. Mind you, when I am reduced to a frozen lump sitting on the edge of a cold, wind-blown estuary, my fingers unable to grip the pencil any more, with the thought of dragging my, by now, extremely cold body back to the car, I must admit my thoughts do focus on centrally-heated studios or offices. But all this is a part of sketching. If you don't experience the elements, how can you remember them and paint them realistically? If you are sensitive to nature and accept its conditions, then the sketch that you produce will be the trigger that takes your memory back to the atmosphere of that particular scene.

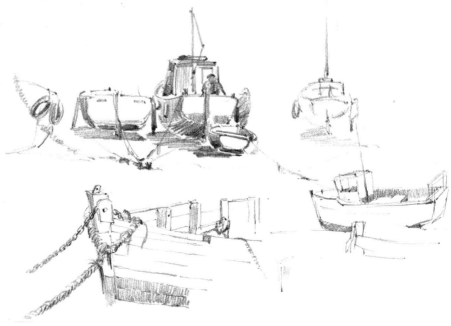

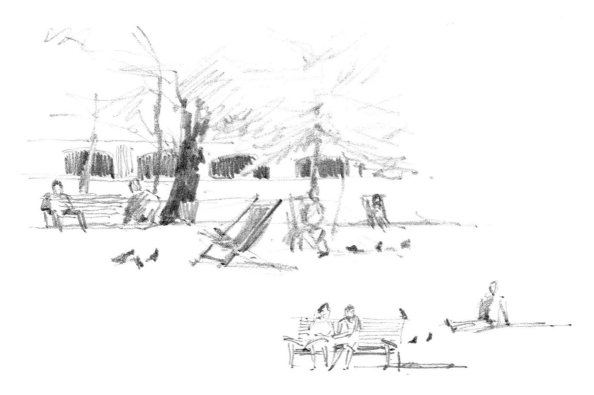

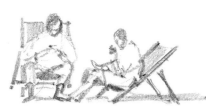

I sketch for different reasons, but mainly to collect information for working up into a painting back in the studio. The information collected in the sketch can be for detail, or for atmosphere. I tend to use a looser technique when sketching an 'atmosphere' sketch, than for a 'detail' sketch (see above for an 'atmosphere' sketch and bottom of page 6 for a 'detail' sketch). Also I sometimes use oil paint for recording atmosphere as I find it is not sensitive enough for detailed sketches.

Another type of sketch is what I call an 'enjoyment' sketch, which simply means that you feel inspired and are just enjoying sketching for its own sake. Naturally, an 'enjoyment' sketch could turn into an 'information' sketch, or an 'atmosphere' sketch, but the important thing is that it was originally done as a piece of creative work for its own sake.

This leads me on to the last type of sketch. A lot of people seem to overlook the fact that a sketch is an artist's visual record of a scene and, as such, is a drawing in its own right. You should never be afraid to frame sketches; in fact, sometimes a sketch from life can have more spontaneity and atmosphere than a painting worked up from it back in the studio.

Every place, or situation, that you sketch has to be carefully observed for you to recreate it as a sketch. Therefore, every sketch you do is increasing your knowledge and experience as a painter. I cannot stress enough the importance of sketching for all amateur painters, at whatever level. Try to make a habit of sketching as much as possible, both for your own enjoyment, and to add to your painting 'repertoire'.

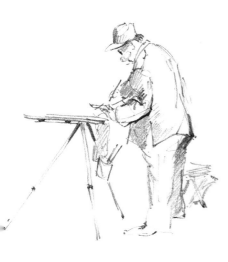

Some artists write a lot of notes on their sketches. I put very little on my sketches, although I might add some initials to remind me of the colours of the fields or buildings. For example, DG = dark green, or PF = ploughed field, W = water, and so on. One thing I often put in a sketch, however, is the sign ⑤, which shows me the sun's position. It is very important in a painting to know the direction of the light. If the sign ⑤ isn't there, the chances are the sun didn't come out!

Use every opportunity possible for sketching

I am fortunate in having been able to cultivate a photographic memory for the different colours of the landscape in all its various moods. This sounds very grand, but it isn't really, and it has only come through many years of observation, training and sketching. I cannot stress enough the importance of really looking at, and studying, what you want to portray in a sketch or a painting. Use every opportunity possible. For example, when I was out fishing and nothing was happening – which was quite usual – I would soak in the atmosphere and think about painting. I might have lost a lot of fish in the process, but I gained a lot of knowledge of nature and how it related to painting.

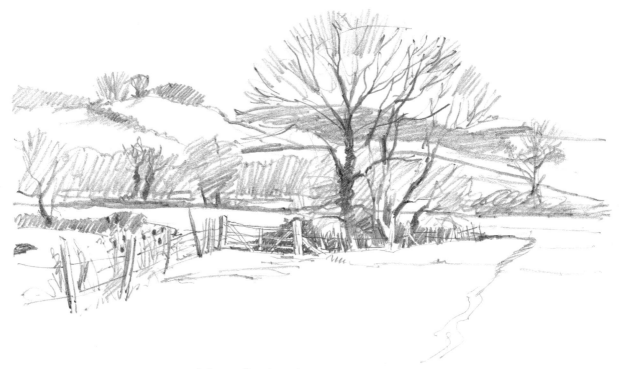

I have lived and worked in the countryside now for years and have gradually come to accept change, although sometimes rather reluctantly, I must admit. But one change that did rather upset my artistic nature was in a favourite haunt down by my local river, where I do a lot of sketching. The sketch above was made there one afternoon in December. It is of a gate surrounded by a group of trees and overgrown brambles. I have sketched this gate from many different viewpoints over the years and it has featured in many of my paintings. One day I went down to sketch the gate and the whole of that group of trees, gate, fence and brambles had disappeared. In its place were large bulldozer tracks cutting deep into the mud, and there was no grass to be seen. I couldn't believe it. In fact, it was hard to visualise what it had been like before the invasion of the bulldozer.

Then, some time later, I noticed that the field was full of bright, shiny metal semi-circular huts, and soon afterwards, running in and out of the huts, were lots of little piglets, with their mothers either lying in the huts, or in the muddy field. It is amazing how pigs turn a field into mud! Almost overnight one of my old sketching haunts had completely changed.

Incidentally, the pigs didn't get away with it. I sketched two of them here and they looked just as dejected as I felt when I sketched them.

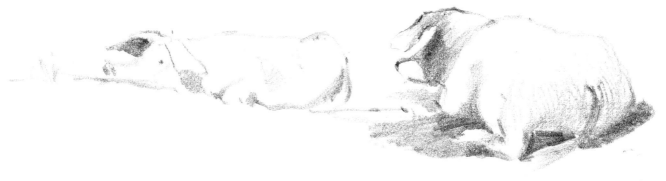

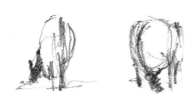

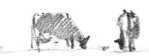

Nature, too, changes the look of the countryside quite a lot. Dutch elm disease has killed off nearly all our elm trees in the last fifteen years or so. If one can have a favourite tree, then the elm was mine. I still use old sketches of elm trees and work them into landscape paintings when I am not copying from nature. I was talking to someone who lived in my village before the elm trees were cut down, who told me that in the summer you could walk in the pouring rain from the village to the local town two miles away, without getting wet. The reason being that the elms on either side of the road made an umbrella of leaves to protect you from the rain. I have only ever seen this road without elms and when I was told this story I felt quite sad.

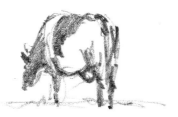

But thinking positively (and one has to for the elms won't come back!), you can now see over the hedgerows between the few trees that are left (mainly oaks and ash) and enjoy a panoramic view of the surrounding countryside, which I am sure would have been impossible with all those tall elm trees there.

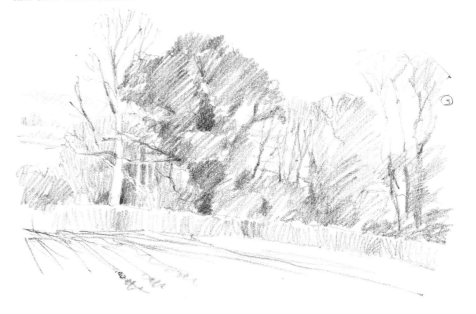

The sketch above of a group of trees at the top of a hill, was made on one of my local walks. On the other side of the hedge is a bridle path that drops down very steeply to the left. The inspiration for doing this sketch was the rich autumn colours of that early November afternoon, with the

sunlight catching the dead elm tree on the left. When we came to live here six years ago that elm tree, although dead, still retained its bark and many small branches. Gradually, however, I have watched the small branches get broken off one by one and the tree lose its bark. I drew this sketch a couple of years ago, knowing that one day soon, if the tree wasn't cut down it would fall down.

One day in late spring we had some very strong gales and storms, and the elm couldn't take it any longer. Previously, when I had looked out of my studio windows I could see the top half of the tree, but on this particular morning it was no longer there. I decided to go up the hill to have a look and to sketch the tree. Near the top of the hill, I could see it completely blocking the path and spilling over into the field opposite, and it had taken with it branches from other trees that were in its path. As I walked up the hill towards it I saw a large tree root curving out of the soil, which I made a mental note to avoid on the way down.

Eventually I reached the tree. It was enormous and had crashed right through the hedge and smaller surrounding trees as though they didn't exist. I really felt inspired to sketch it with its silver-white trunk in stark contrast to the other trees, mellow in the hazy sun. I was pleased with the sketch I had done and, walking back home, I was deep in thought and self-admiration, when I felt my left foot being held back. I was walking downhill and there was no way I could get my foot out from under that protruding root, and I went headlong into the mud. It was then that I realised that earth is actually made up largely of stones – or it is in my

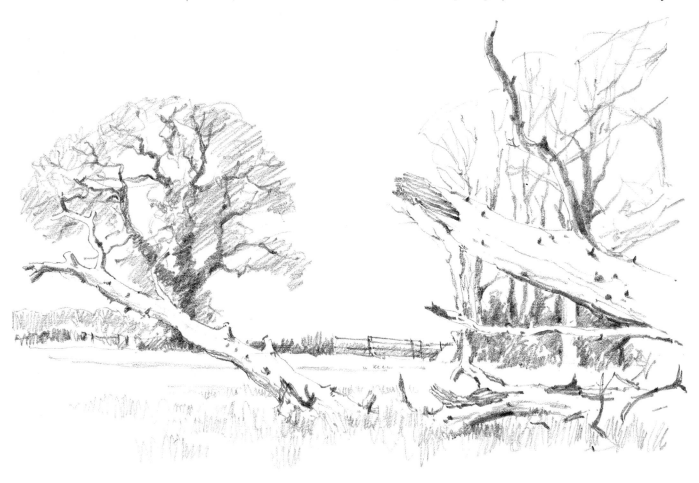

area! I lay there for a while surveying the damage and I couldn't understand why, even after I had fallen, my arm was still held aloft. But there it was – my sketchbook, unmarked and clean. As I fell, my hand holding the sketchbook must automatically have gone up to prevent it from being crushed as I hit the ground: the sign of a true professional?

You do not need a lot of equipment for sketching

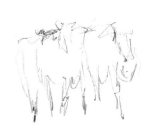

The great advantage of sketching, and in particular pencil sketching, is the small amount of equipment you need to carry around – one pencil, usually a 2B, and a sketchbook. I always keep a small A5 size sketchbook in the car together with a couple of pencils. This means that whenever I get an opportunity to sketch I have the equipment to hand. You may wonder why only a small sketchbook, if I'm in the car.

Firstly, the small sketchbook fits into the glove compartment and hides away, leaving me with no visual reminder of work when I am out in the car. Although I live for my work, it is good to break away from it sometimes. I find that driving is a good way of topping up your visual memory with atmosphere and knowledge of the landscape, and nature. Driving teaches us to observe: to look out for obstructions on the road ahead, to be aware of road surface conditions, and so on. We look at the sky to determine whether it will rain or not; we see the trees blowing in a strong wind; and we notice a mist hanging over a river in the late evening. When you see all these various conditions on the road, or in the surrounding countryside, try to see them with an artist's eye. Try to remember how the sky looked before it rained, or how it looked when it was only raining in the distance; how thick the mist was, and how it followed the course of the river.

The second reason for using a small sketchbook when out in the car is because the time in which I have to sketch is usually short. Perhaps I have stopped in a lay-by for five minutes, waiting for some cows or sheep to pass by, or I'm waiting in a car park for the family. If I was using a large sketchbook, the knowledge that I had perhaps only five or ten minutes in order to fill the page might be too daunting. I personally like to fill the whole page with a sketch. In fact, if you look at the sketch of the cows above I had only thirty seconds in which to draw them before the farmer waved us past. Whereas in the sketch below I had five minutes before they were led off the road into the farmyard. Sketching cows (or other animals) from the car is a good exercise I find, and it's amazing how much knowledge I retain in my memory of the way they move and behave. Usually, when you sketch cows in a field they are just standing chewing the cud, or lying down.

Quick sketches are often very successful

The sketch at the top of page 12 is a good example of a quick, impromptu sketch. It was a crisp, sunny January morning and the weather was so inviting that my wife, June, and I decided to drive to Sidmouth, a local seaside town. All the boats and the general hustle and bustle of activity in the late morning sunshine were too much for me to resist. I rushed back to the car, got my sketchbook and pencil, and did several sketches out of sheer delight at my surroundings. They only took ten minutes or so each, and I felt really exhilarated afterwards.

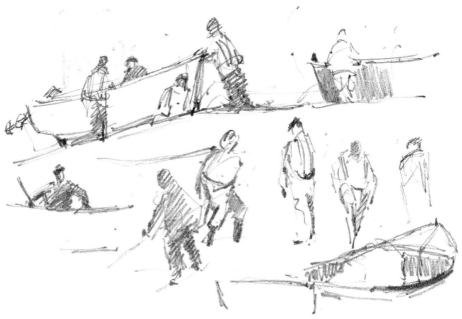

Last year I had to do a demonstration for an art society in Sussex. Naturally I took my sketchbook along with me as I always do, especially since I was determined to sketch, or paint in watercolour a view of Rye, which is one of the old Cinque Ports and very picturesque. I have fond memories of this old town. When I was at Art School in Hastings my friends and I used to cycle to Rye and paint all around the river estuary and harbour. I wanted to find the classical view of the town, with the church on the sky-line and the river winding its way from the town to the sea. I had painted Rye many times in my youth, and yet I didn't have a sketch or painting left of the place.

Driving away from the town towards the coast, I kept looking back to find the view I was seeking and gradually became aware of some large, uninteresting buildings. I didn't remember these buildings and was very put out since, by my calculations, they would be obscuring the view I wanted. I suppose thirty-five years is just too long to expect things to remain the same!

I started looking for other views to sketch and it was these boats (below) that took my eye. They were moored in the river on gorgeous, wet mudbanks so I went down on to the mudbanks, and stood and sketched.

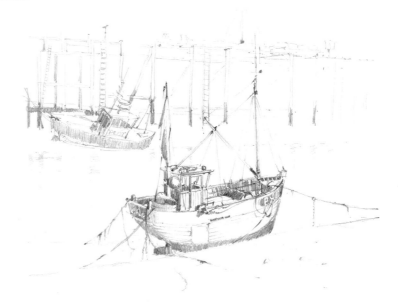

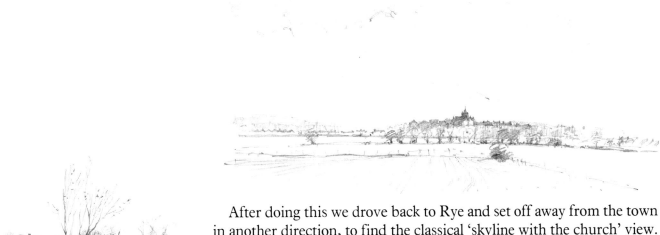

After doing this we drove back to Rye and set off away from the town in another direction, to find the classical 'skyline with the church' view. Eventually, we found the view that I have sketched here. The silhouette of the church and buildings against the bright sky were the inspiration, and so, too, was the vastness of the sky. I live in Devon in the West Country, where the landscape is very hilly and when I come across a flat expanse of land with the full dimensions of the sky, I find the combination irresistible. I later used this sketch to paint a demonstration painting, which appears in my book *Learn to Paint in Oils for the Beginner*.

Train journeys are an ideal time for sketching

When I have to make a long train journey I always look forward to it, knowing that I will be able to do some sketching from the window. Train journeys provide an ideal opportunity for sketching and I recommend that you take advantage of them. One of the most basic skills of sketching, or painting, is learning to observe and on a train journey you can do just that, sometimes for several hours. It is both enjoyable and useful as an artist to sit and look out of the window and watch the landscape passing by. When the train is travelling through open countryside you will be able to see the sky and watch how the clouds

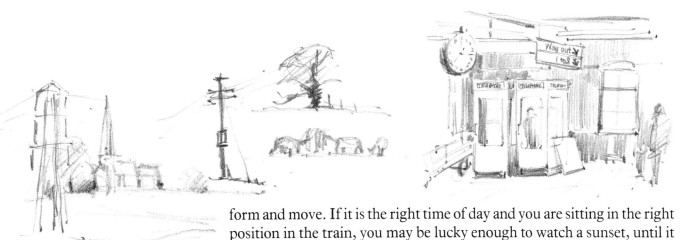

form and move. If it is the right time of day and you are sitting in the right position in the train, you may be lucky enough to watch a sunset, until it has disappeared below the horizon and all you are left with is your own

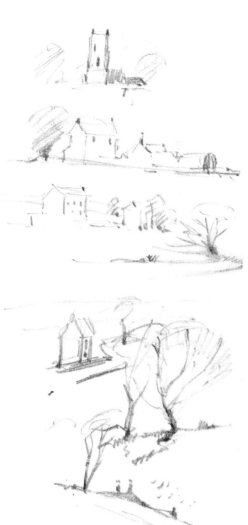

reflection in the darkened carriage window. You can make a mental note of the colour of the distant hills in contrast to the ones near the train and notice just how blue they are.

The visual information that you can collect on a train journey is very valuable – it really is a good opportunity for sketching. Naturally, sketching from a window of a train travelling at very high speeds means that detailed work is impossible! All I look for are basic shapes and form, and I try to draw them as quickly and as economically as possible. I find that I often use these sketches for reference in larger paintings, and the visual memory of the scene usually comes back to help. For detail and colour I have to rely on my experience of working out-of-doors for many years. One word of caution though, only choose something a fair distance away from the train as it takes longer to pass, and you gain a few more seconds to sketch it.

The River Exe estuary in Devon is one of my favourite painting haunts. It has mud flats, sand dunes, boats, Victorian buildings and a bird sanctuary. I also discovered that it had some bird-watchers' hides well camouflaged in the estuary surroundings. The day we came across them was all very embarrassing. June and I had walked along the mud flats, looking for inspiration for sketching. I had done a couple of small sketches but I wanted to get closer to the water's edge to sketch some buildings on the other side of the small bay.

In the bay, on a large mudbank formed by the receding tide, were many cormorants and there were other birds wading around in the mud looking for food. As we walked quietly along, pausing every now and then to survey the scene with a view to sketching, we were completely taken by surprise by a lot of angry shouting further up the mudbank towards the sand dunes. We followed the sound and it seemed to come from a low, dark shape nestling in sand, long grass and brambles – it was a bird-watcher's hide. Now if the bird-watchers had been patient, we would soon have walked out of the line of their binoculars and cameras, and no harm would have been done. Incidentally, we hadn't seen any notice warning people about walking in the area and the hide was well camouflaged, not only from the birds, but also from passing artists.

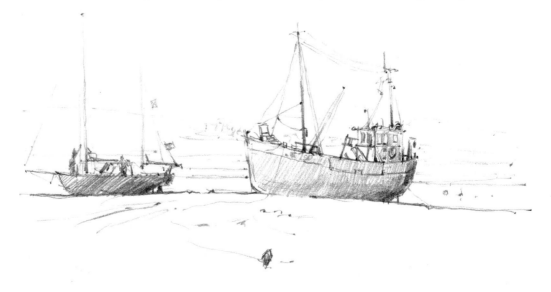

Our walking by had no effect on the birds, but the shouting certainly did, for flocks of birds took flight. I suppose that even good-natured bird-watchers can get out of bed on the wrong side, as indeed artists can!

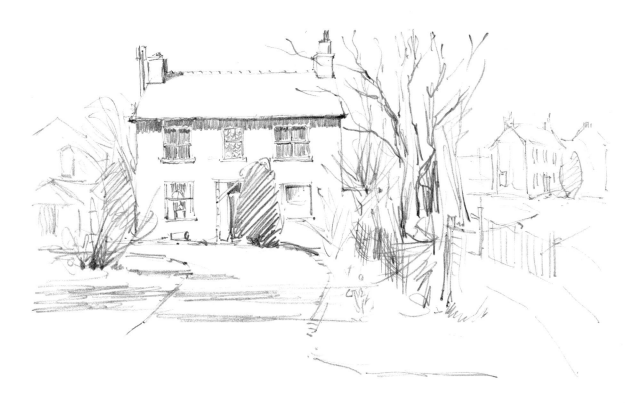

The sketch above was done purely for sentimental reasons. My wife and I were visiting Yorkshire, the county where I was born, and I was doing some painting there. I had never seen the house where I was born (I left Yorkshire when I was 11 years old), and I wanted to find the house and sketch it. Some very good friends from childhood days told me where it was and here is a quick sketch of it.

Every sketch tells a story ...

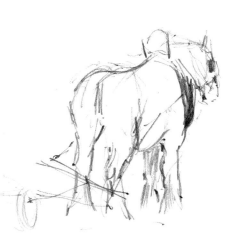

Every sketch in this book tells a story, long or short, funny or nostalgic. In fact, very few of my sketches of real places were done without something notable happening, either on the way there, during the sketching time, or on the way home. So they become very important visual momentoes for me. In fact, the sketch at the top of page 16 tells quite a tale, and it serves as a reminder to the artist who always checks everything, because, like me, you too can be fallible!

I had a painting demonstration to do in a large art shop at Redruth in Cornwall. The next day, after the demonstration, my wife and I went off in search of some of the lovely old Cornish harbours. It was a warm, sunny spring day. I had my sketchbook with me and my camera loaded with a new film. The way I work on a trip like this is that when I haven't the time to sketch in watercolour or oil, I sketch in pencil and take a photograph of the scene as well. If at a later date I want to do a painting from the sketch, and I need technical references, e.g. the correct rigging on boats, architectural details of buildings, the colours of things etc., I

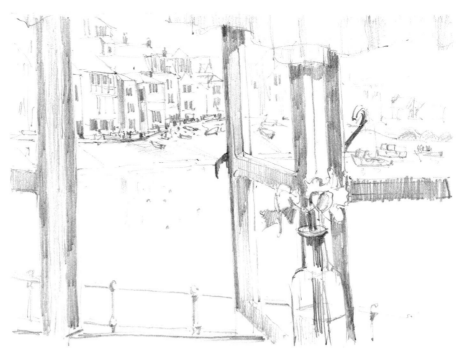

have a transparency of the view as an aid in addition to a sketch. As I have said earlier, I am quite happy to work from pencil sketches of landscapes and subjects that do not contain too much technical detail. But a well-known harbour scene, for example, is a different matter. The artist must not paint the houses the wrong colour, put too many windows in, or miss out the local fishermen's memorial.

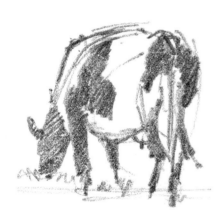

You either need to spend many hours sketching putting in every detail and colour or, as I do on these occasions, get a feel for the place by sketching it and then use the photograph to check detail and colour where necessary. On this particular day everything was going perfectly. I had done some sketches in the morning and taken some photographs. Then we found a restaurant that overlooked the harbour and had lunch. I also did a sketch through the open window and was very pleased with it and determined that I would use it for painting up into a large acrylic painting. Although the buildings and boats were in the distance, I would also need a photograph to help with recreating the scene in detail from my pencil sketch, so I took three photographs of the scene from different angles.

At about four in the afternoon we had finished sketching and photographing the picturesque fishing village, and were feeling tired but contented. I needed another film for my camera as I had finished my reel of 36, so we stopped outside a shop that sold films, I started to rewind my film back on the spool, but it was winding too easily – there was no tension. Something was wrong! Into my mind came the joke that is always heard at weddings and important functions: 'I hope you've got a film in that camera . . .' I will leave you to work out the rest of the story!

I could write stories about all the other sketches reproduced in this book, but, of course, there isn't room. However, where I feel a few notes are needed you will find them captioned on the particular page. I hope you enjoy my sketchbook and if you haven't picked up a pencil since you were at school, perhaps my sketches will inspire you to start sketching.

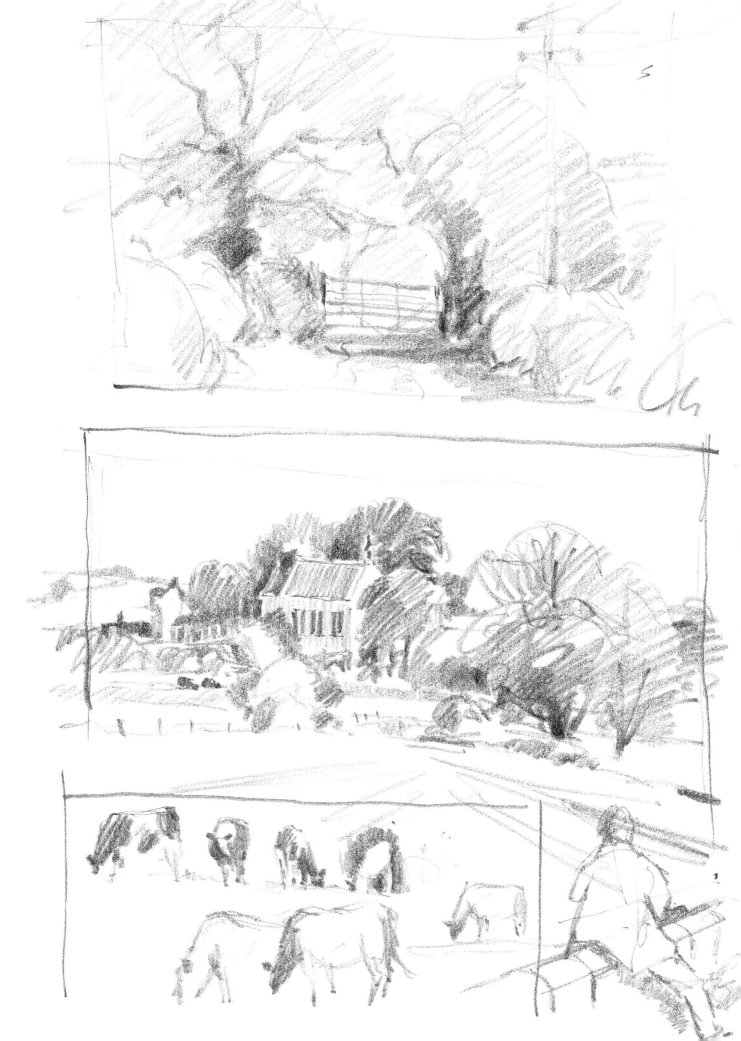

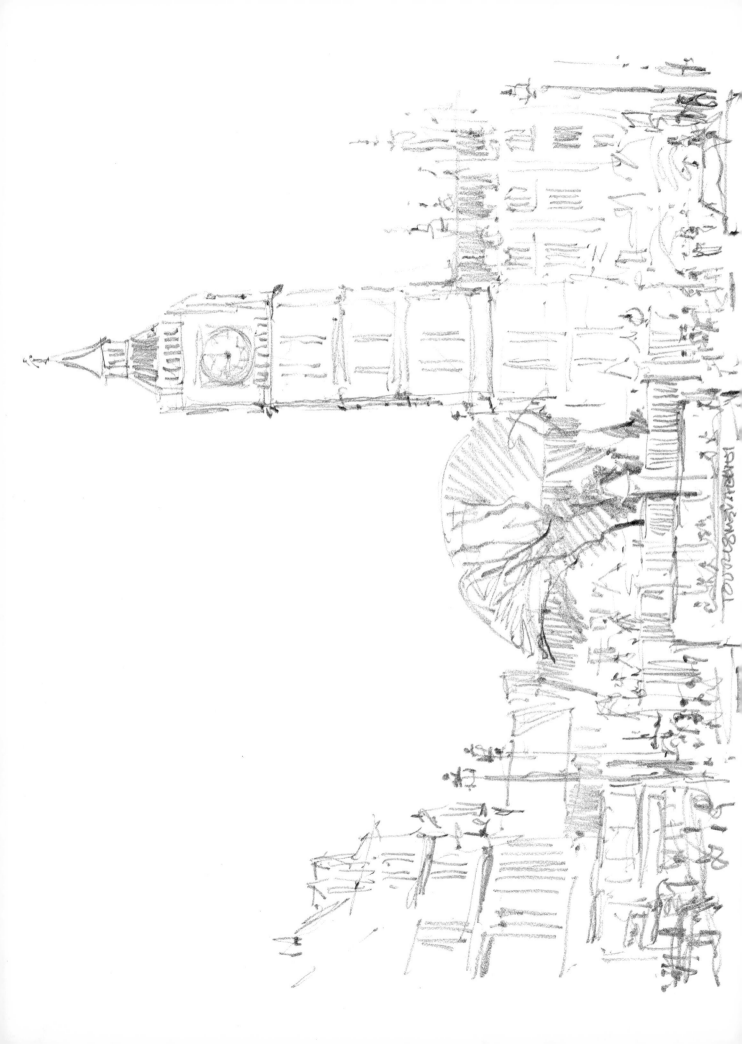

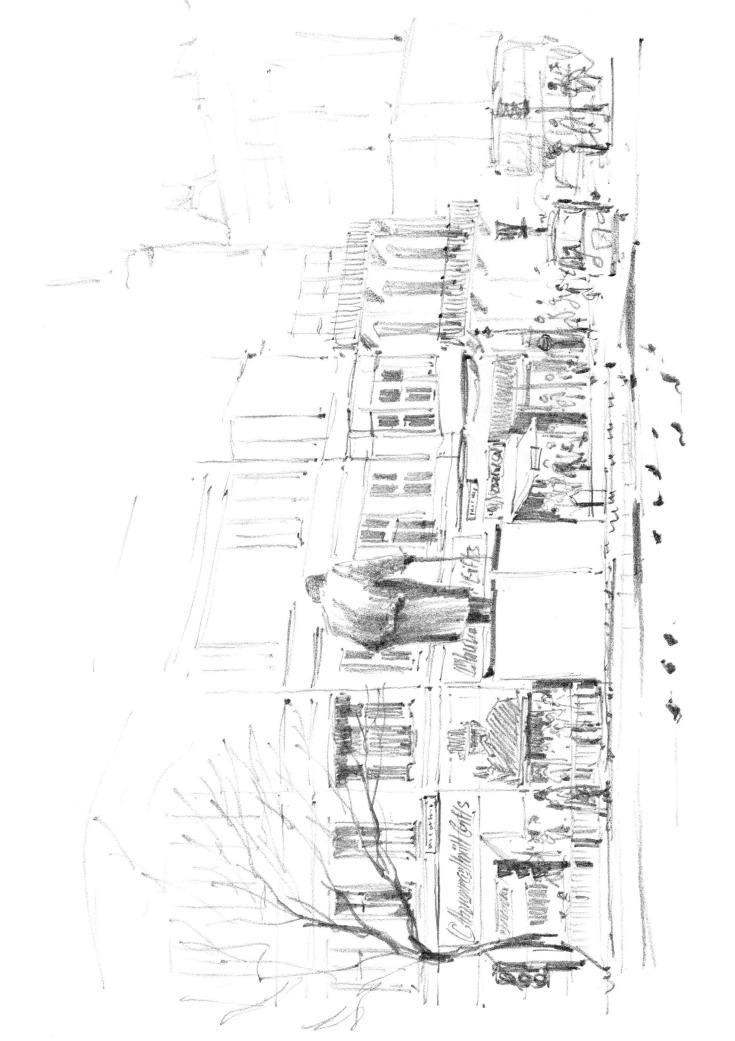

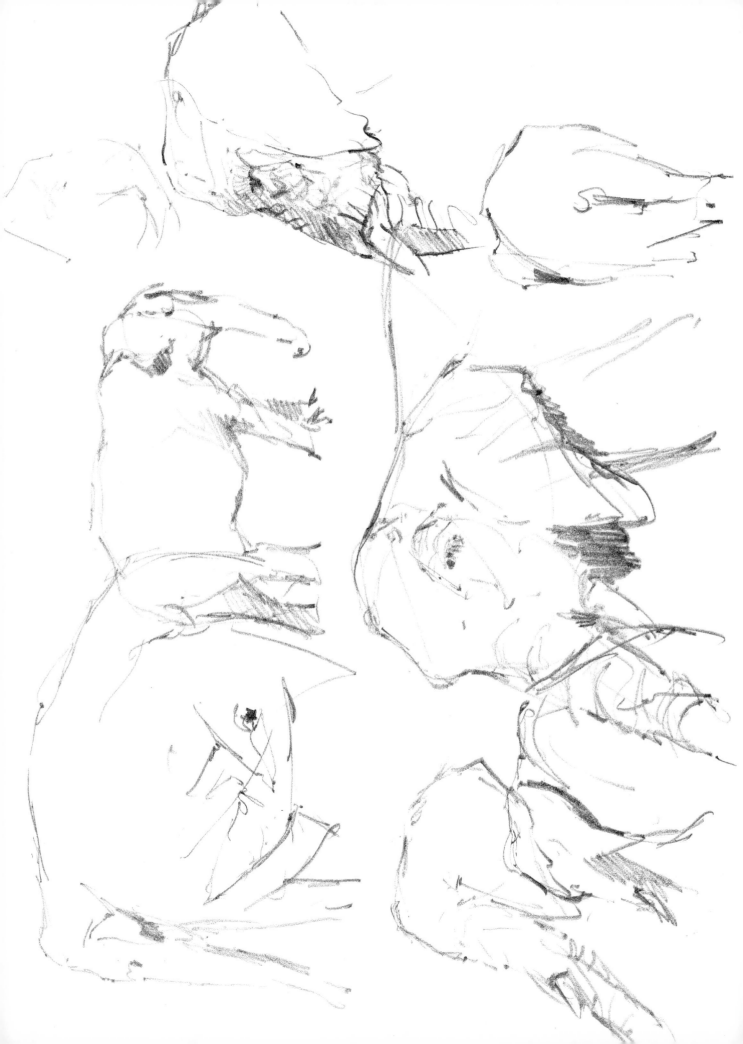

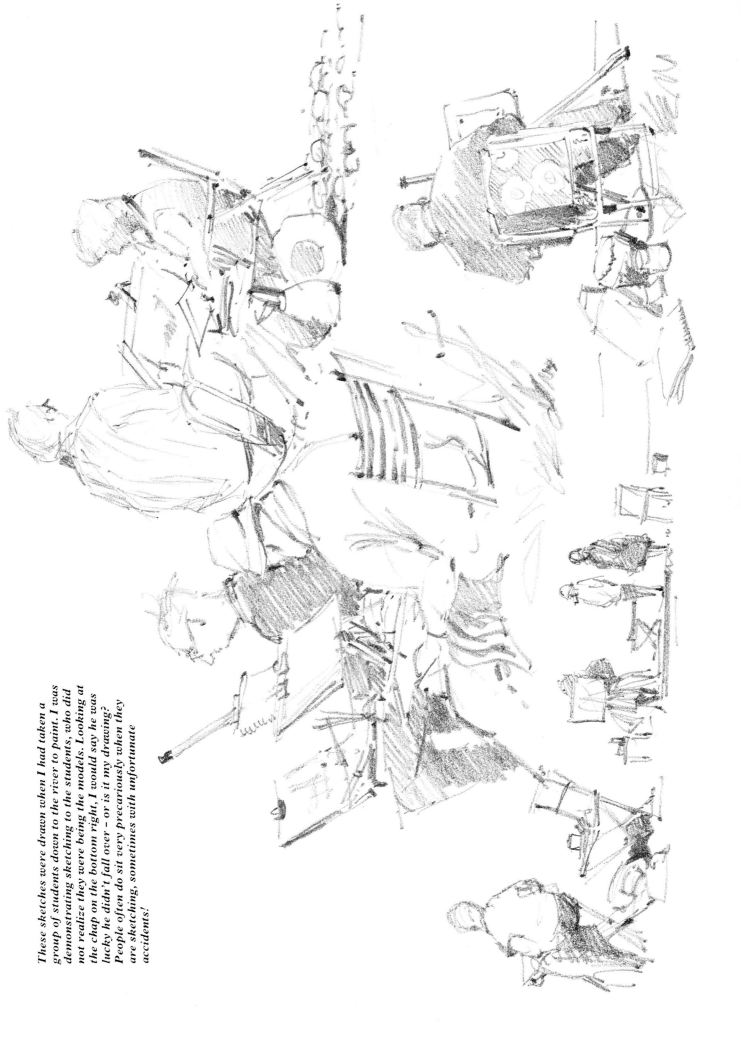

These sketches were drawn when I had taken a group of students down to the river to paint. I was demonstrating sketching to the students, who did not realize they were being the models. Looking at the chap on the bottom right, I would say he was lucky he didn't fall over – or is it my drawing? People often do sit very precariously when they are sketching, sometimes with unfortunate accidents!

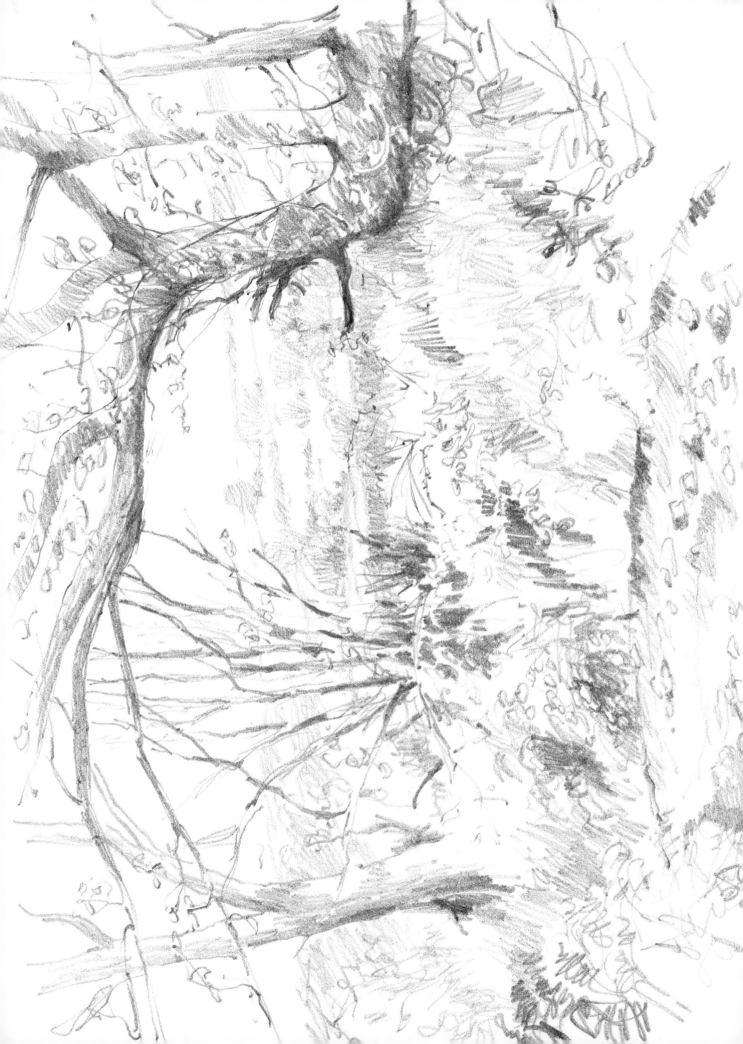

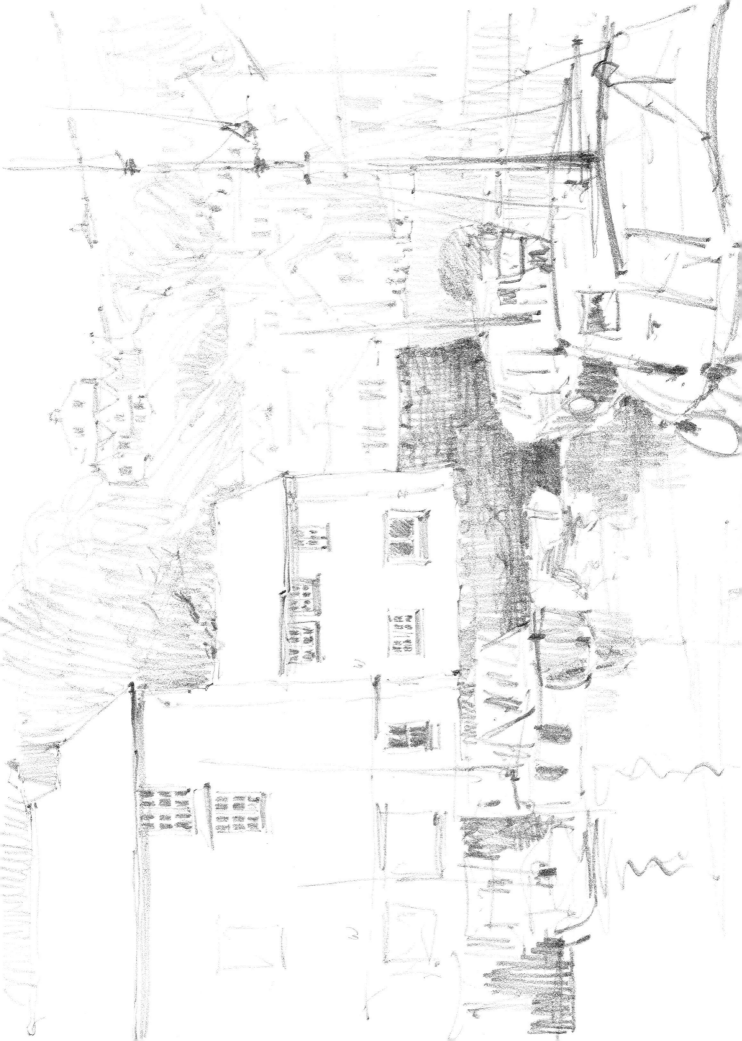

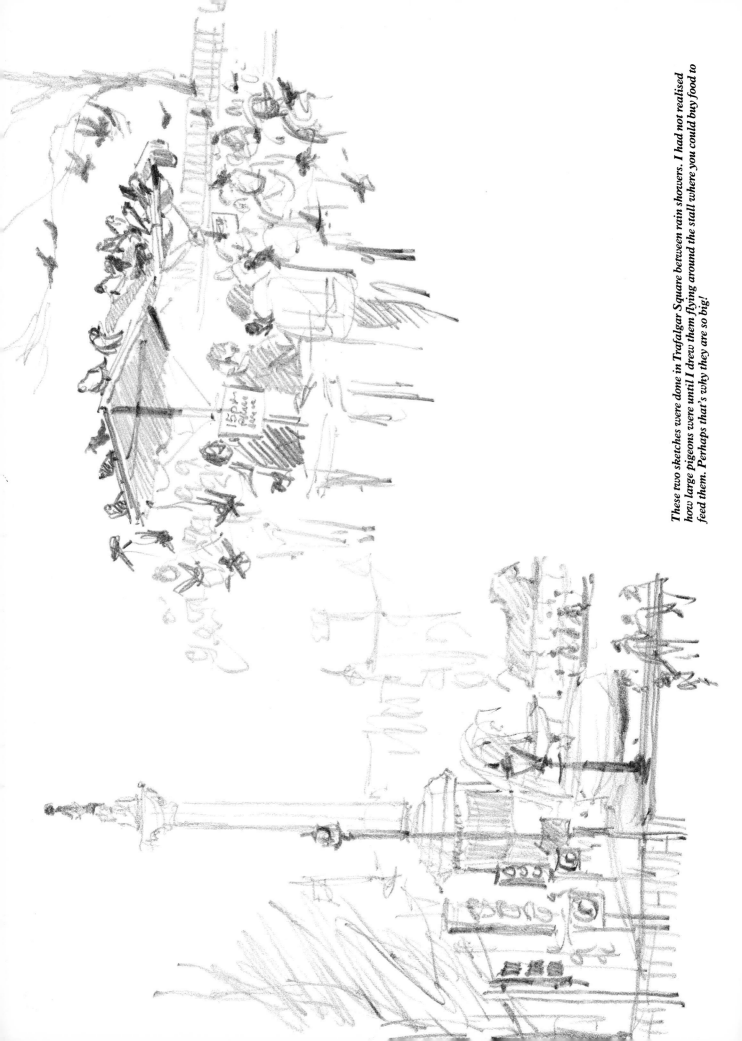

These two sketches were done in Trafalgar Square between rain showers. I had not realised how large pigeons were until I drew them flying around the stall where you could buy food to feed them. Perhaps that's why they are so big!

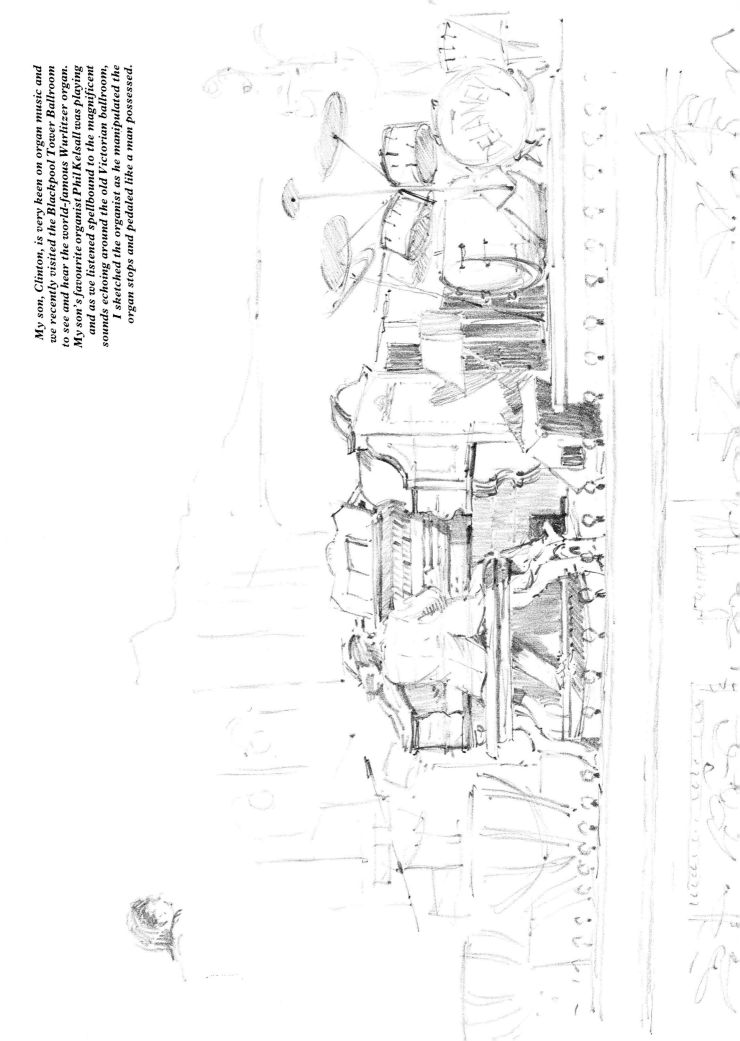

My son, Clinton, is very keen on organ music and we recently visited the Blackpool Tower Ballroom to see and hear the world-famous Wurlitzer organ. My son's favourite organist Phil Kelsall was playing and as we listened spellbound to the magnificent sounds echoing around the old Victorian ballroom, I sketched the organist as he manipulated the organ stops and pedaled like a man possessed.

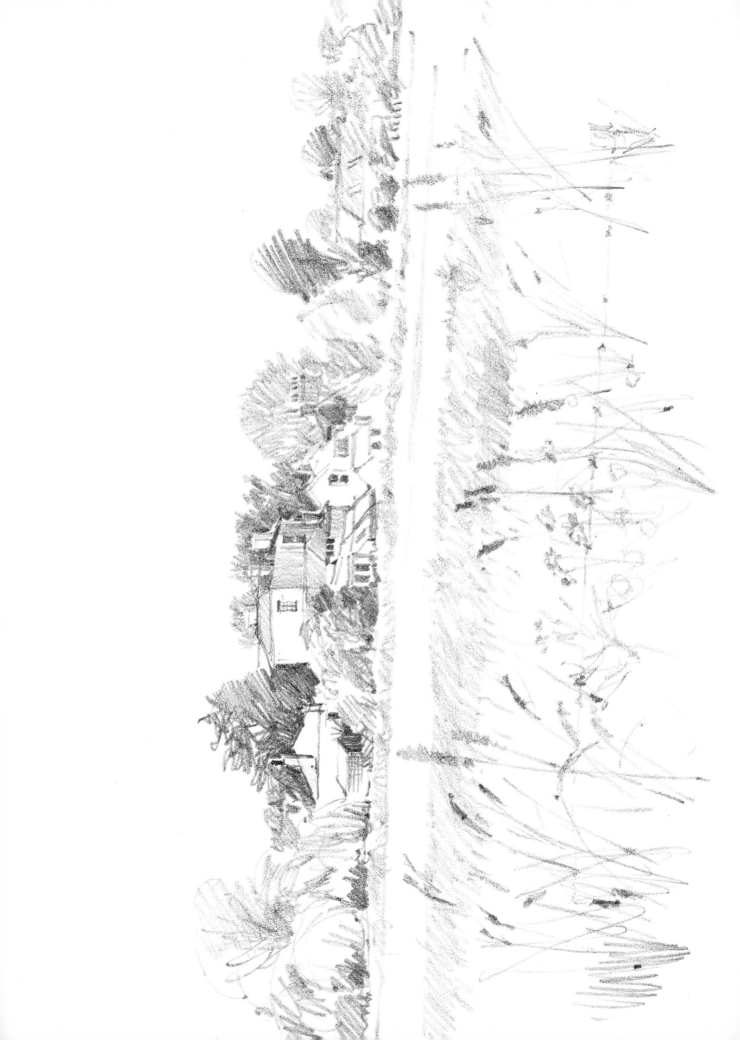

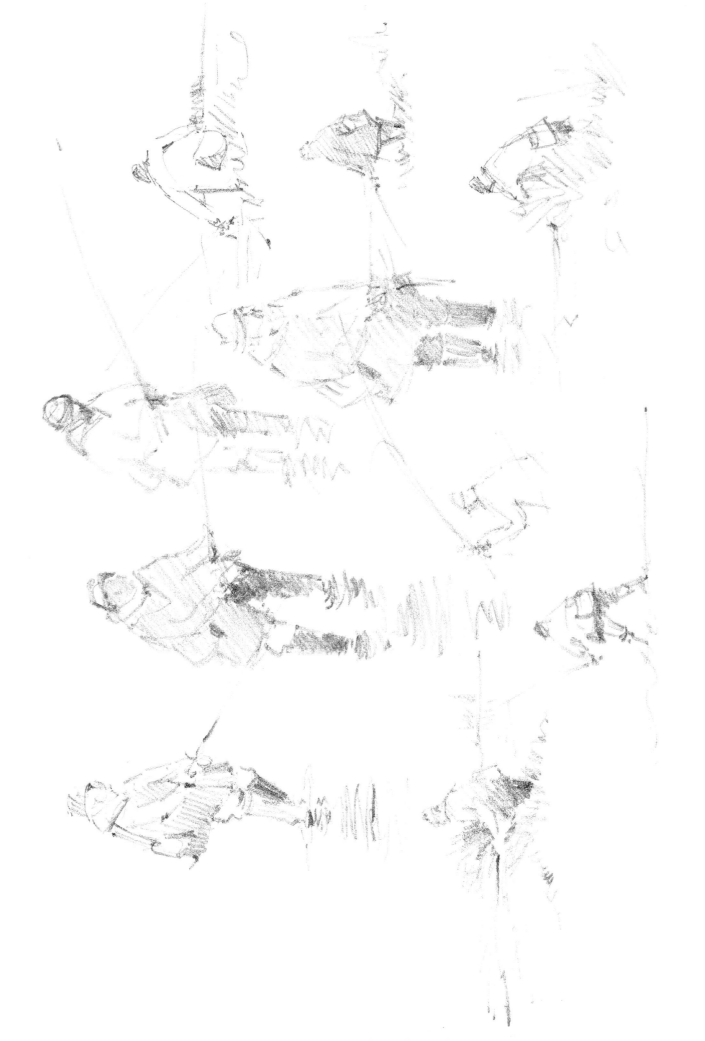

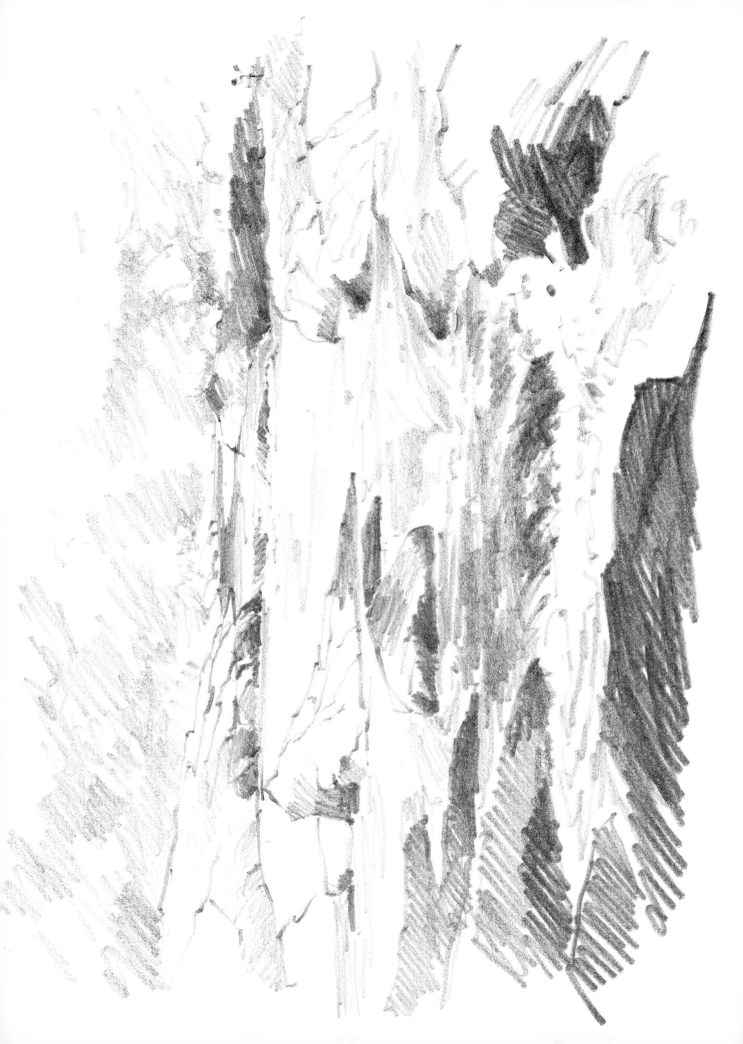

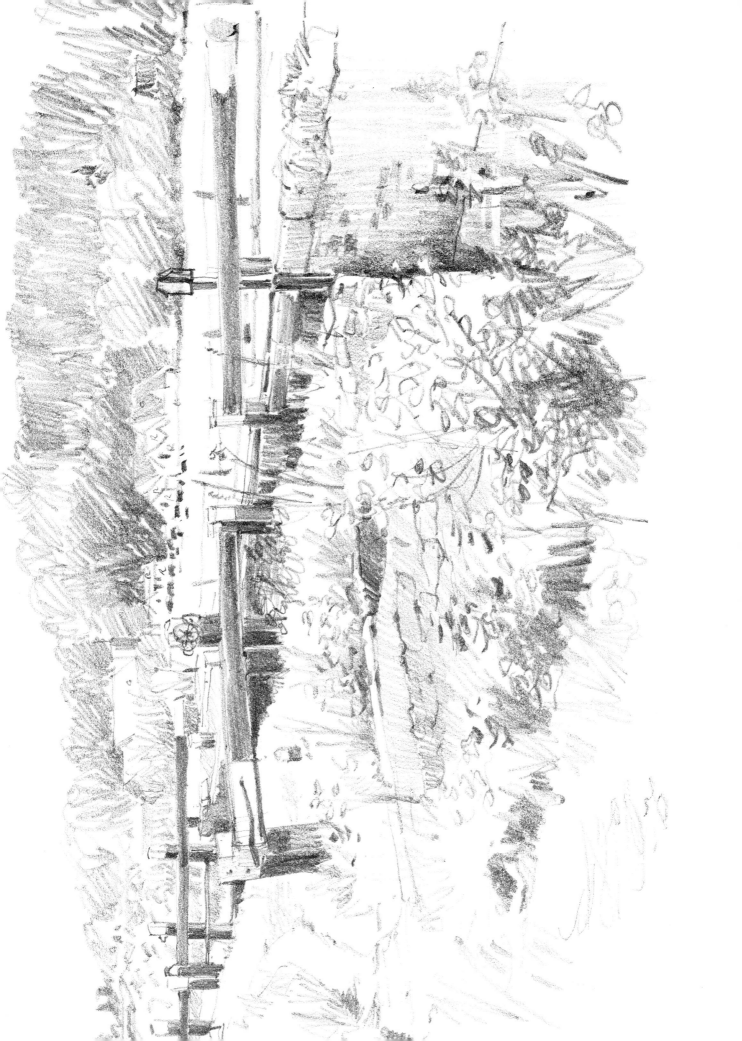

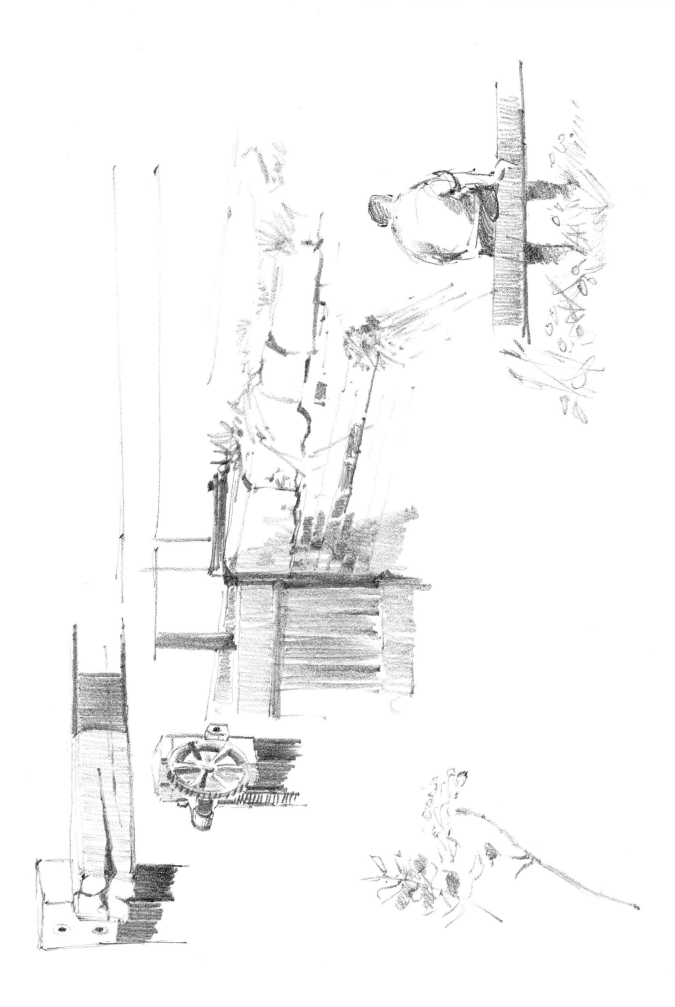

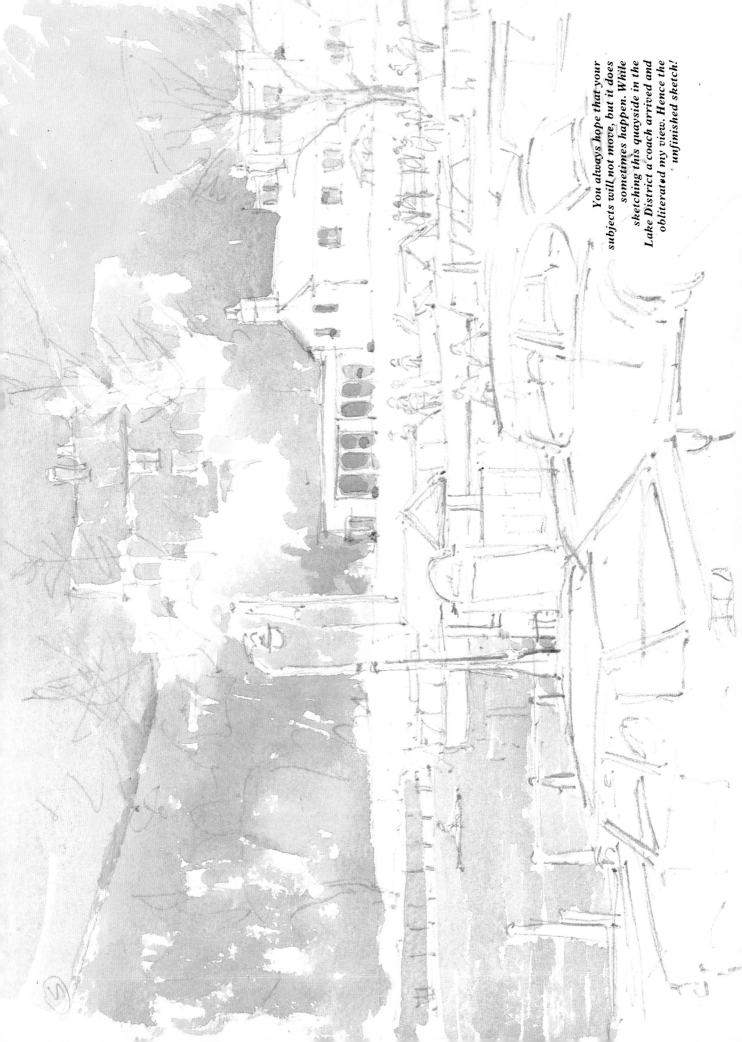

You always hope that your subjects will not move, but it does sometimes happen. While sketching this quayside in the Lake District a coach arrived and obliterated my view. Hence the unfinished sketch!

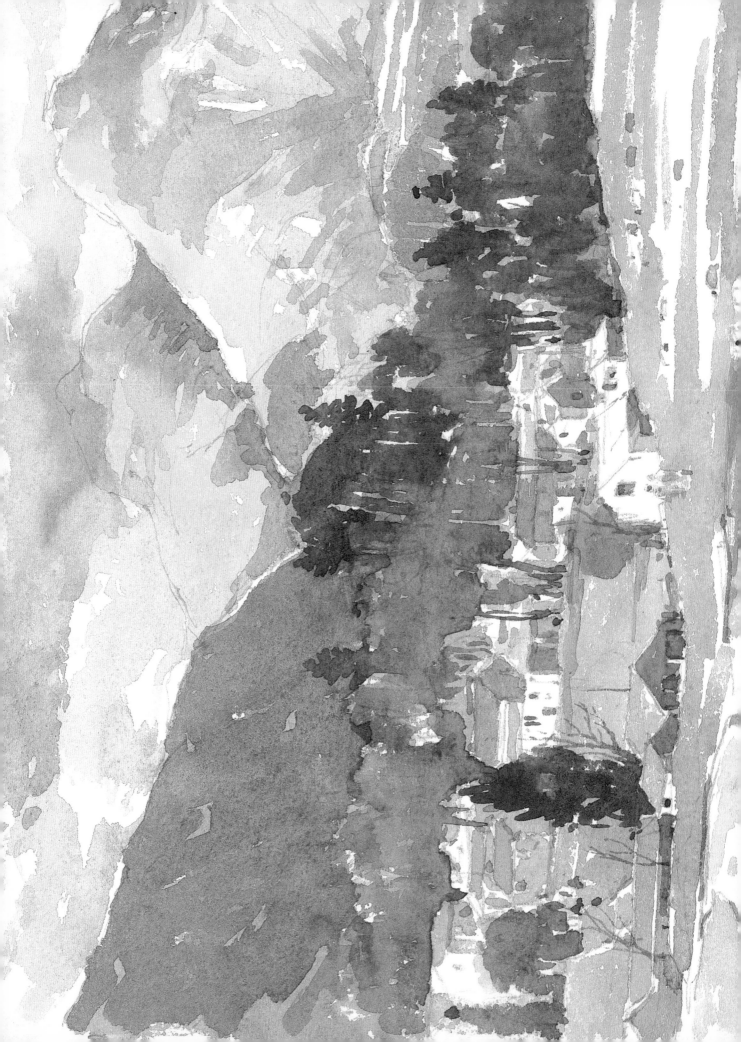

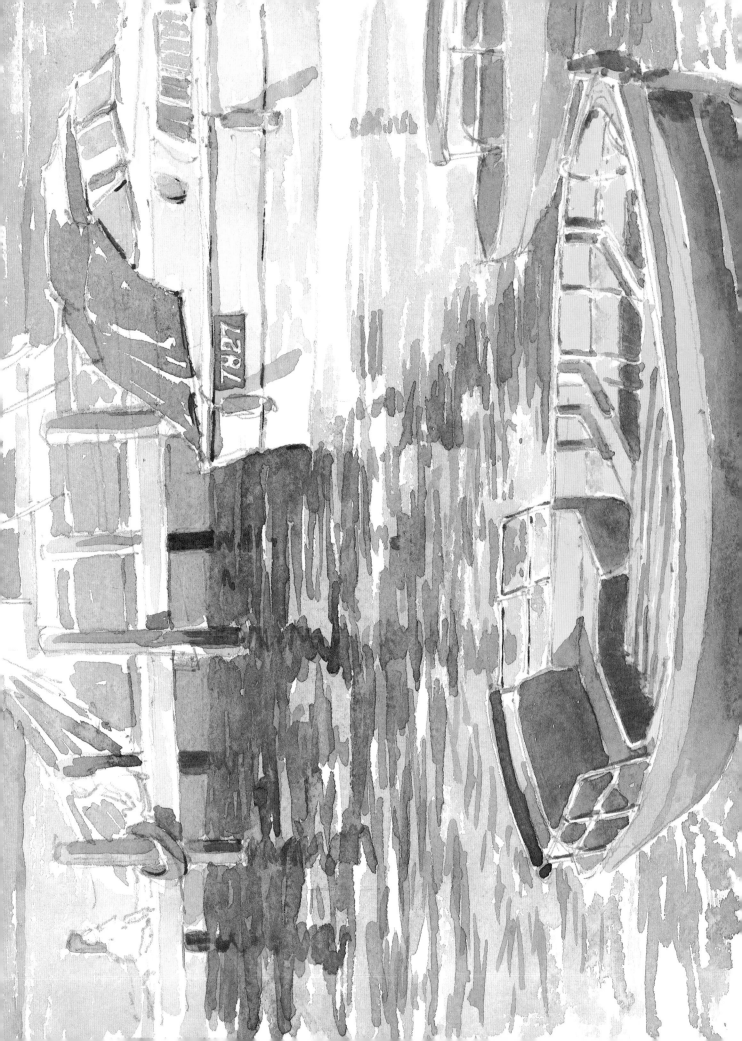

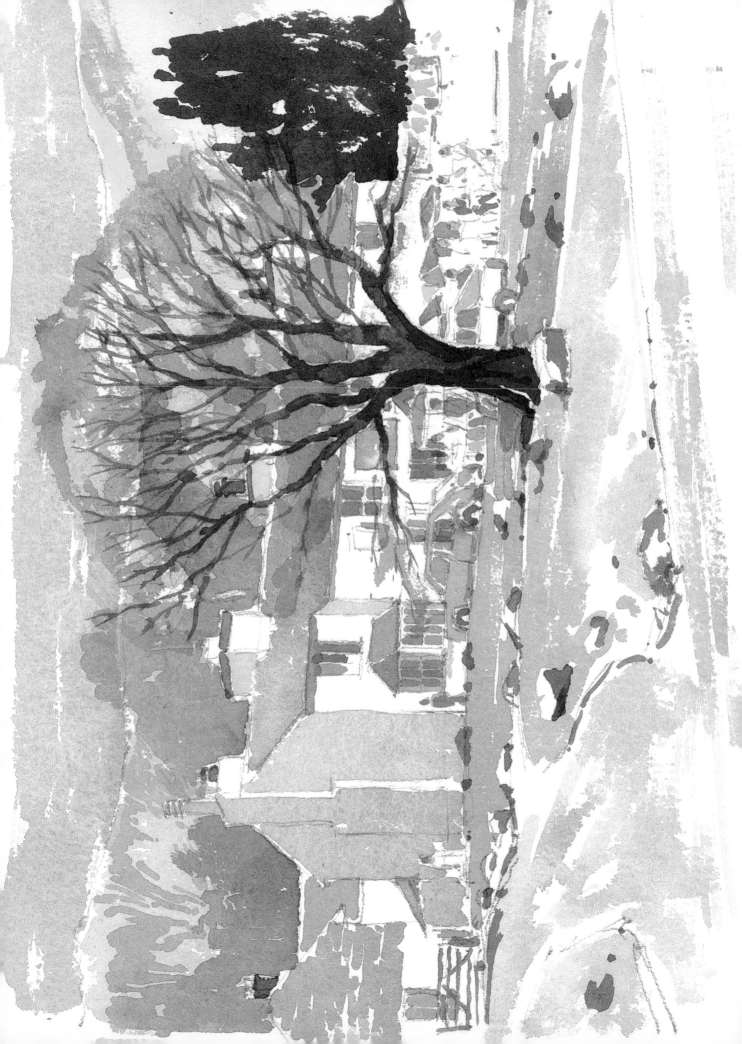

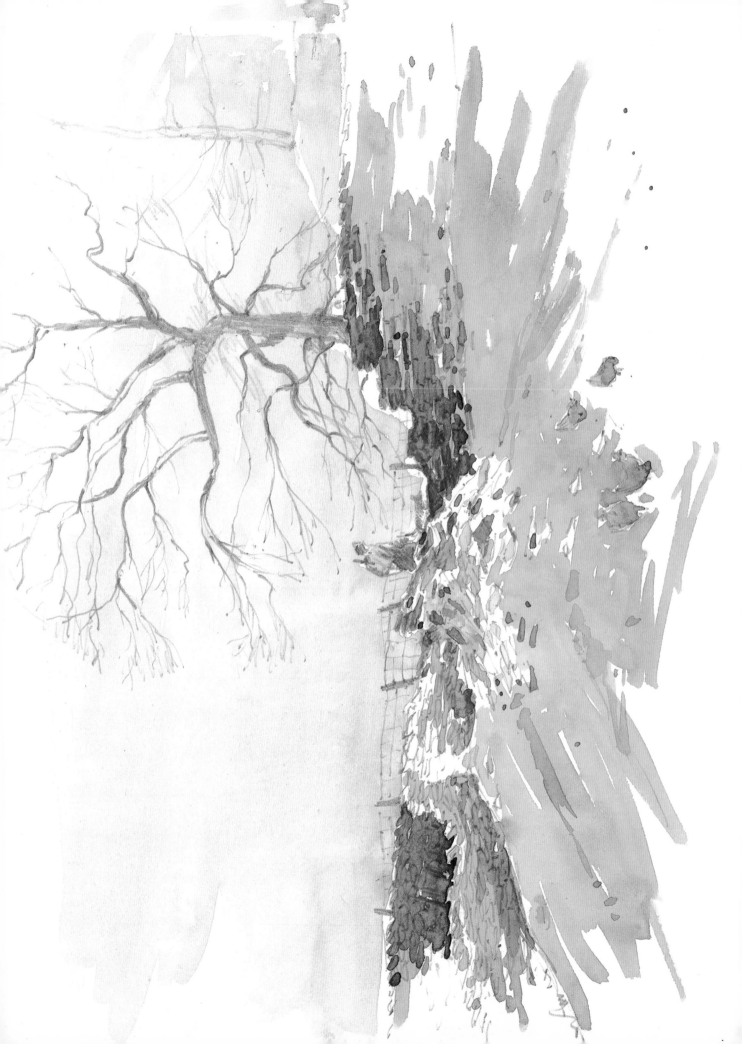

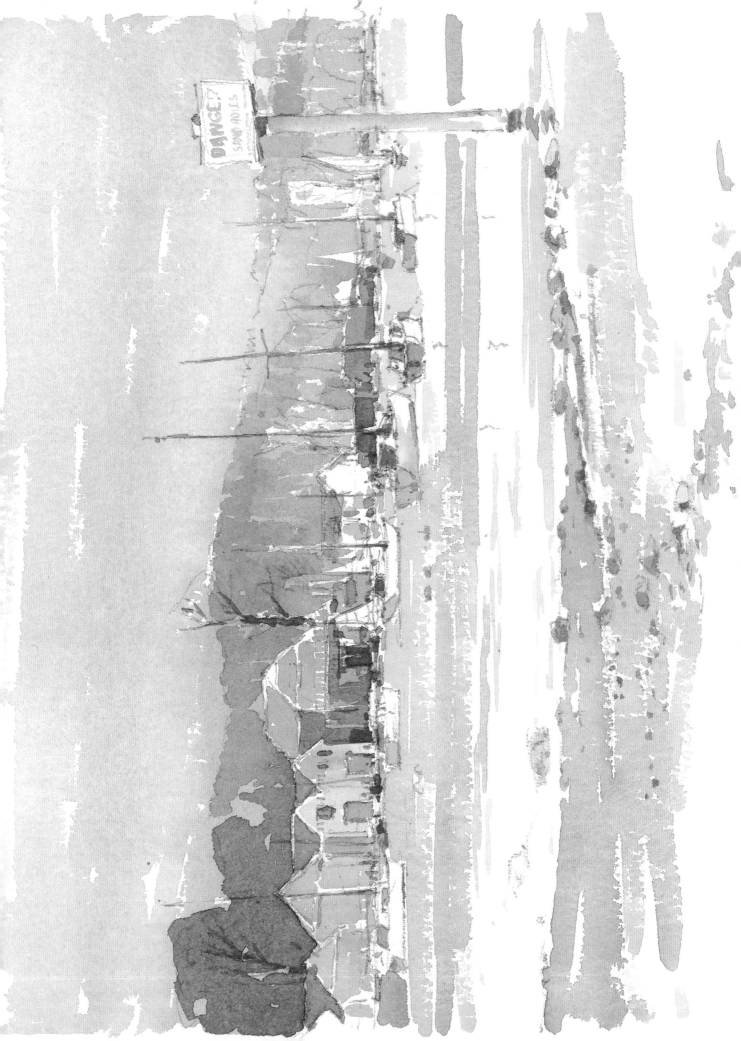

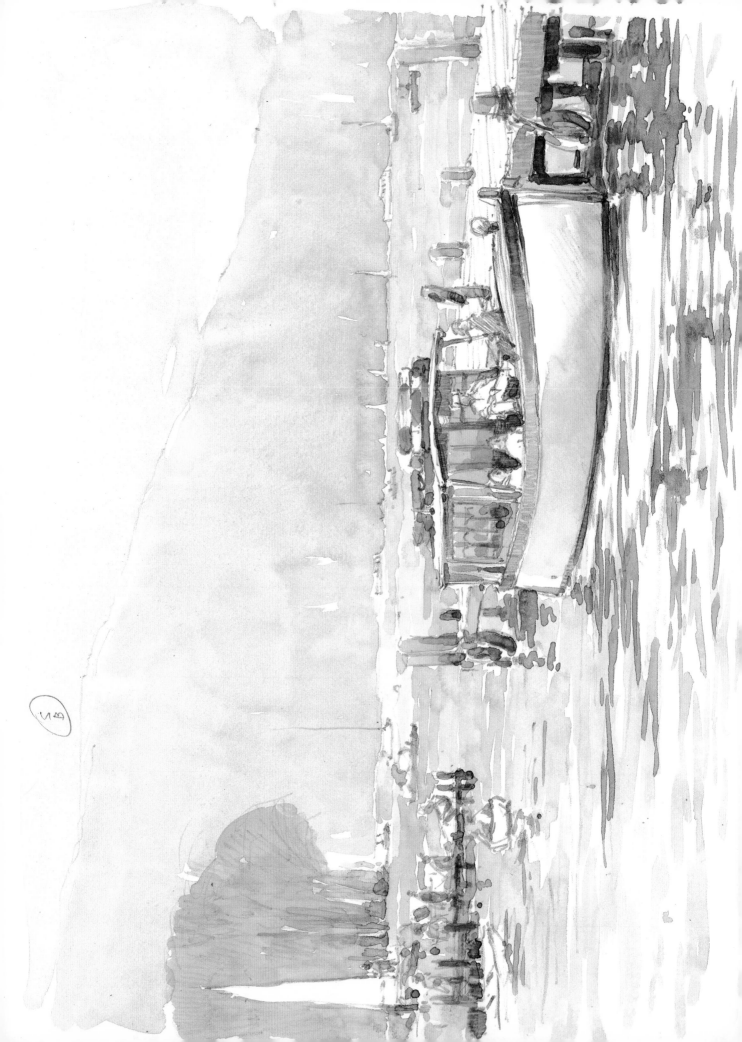

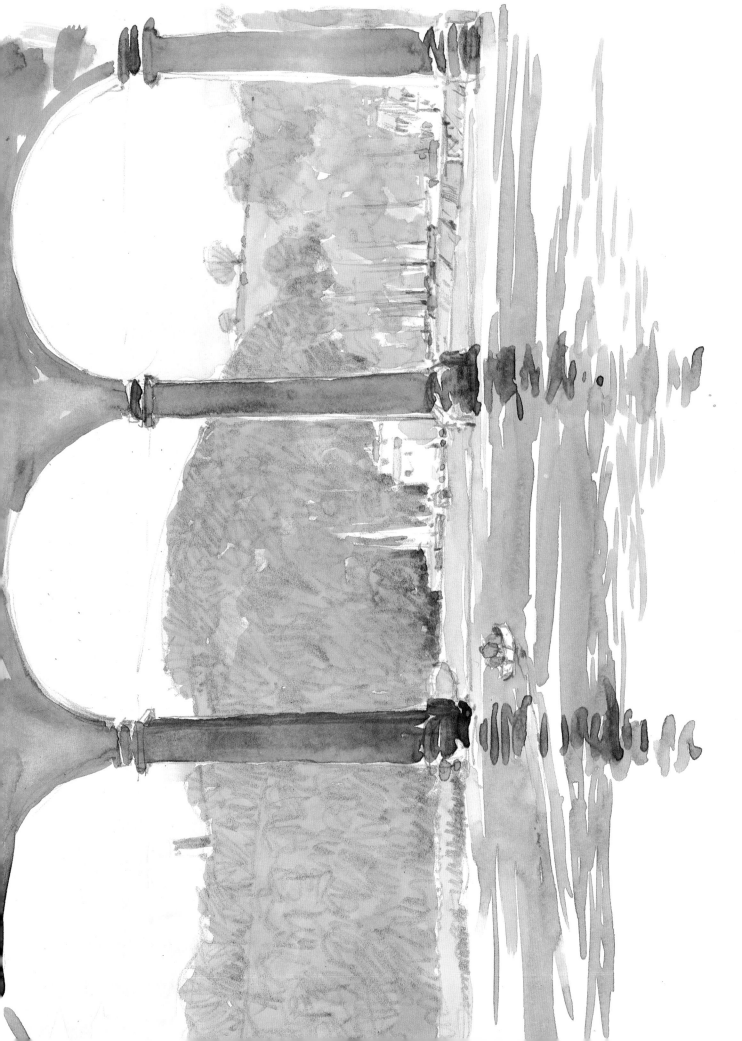

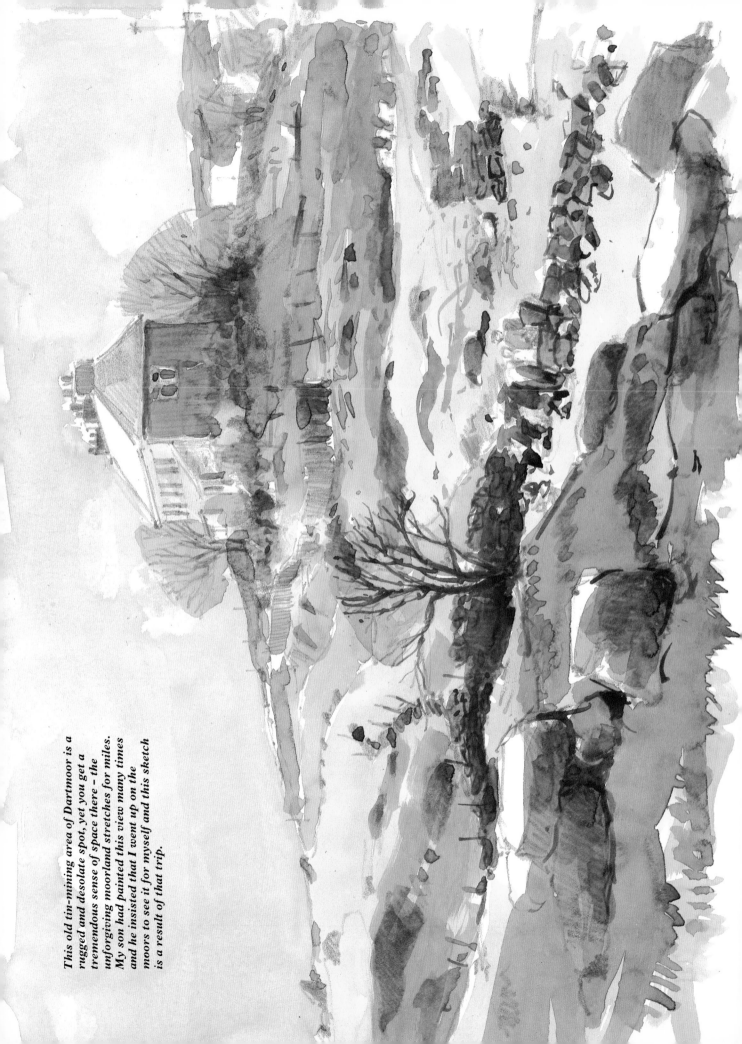

This old tin-mining area of Dartmoor is a rugged and desolate spot, yet you get a tremendous sense of space there – the unforgiving moorland stretches for miles. My son had painted this view many times and he insisted that I went up on the moors to see it for myself and this sketch is a result of that trip.

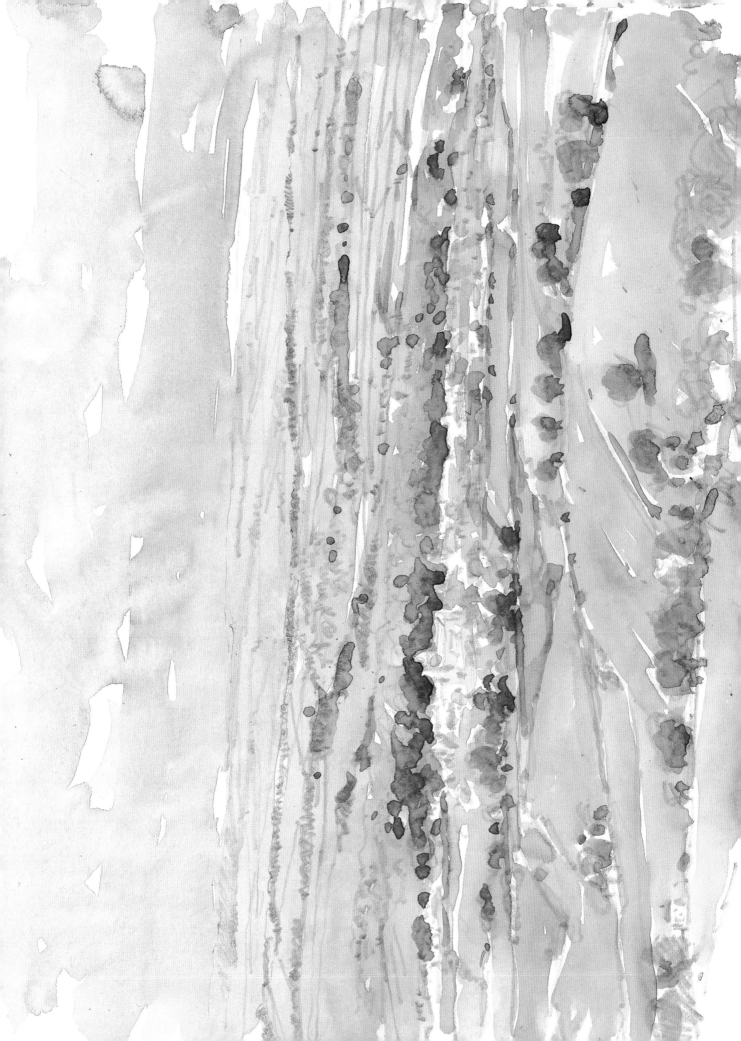

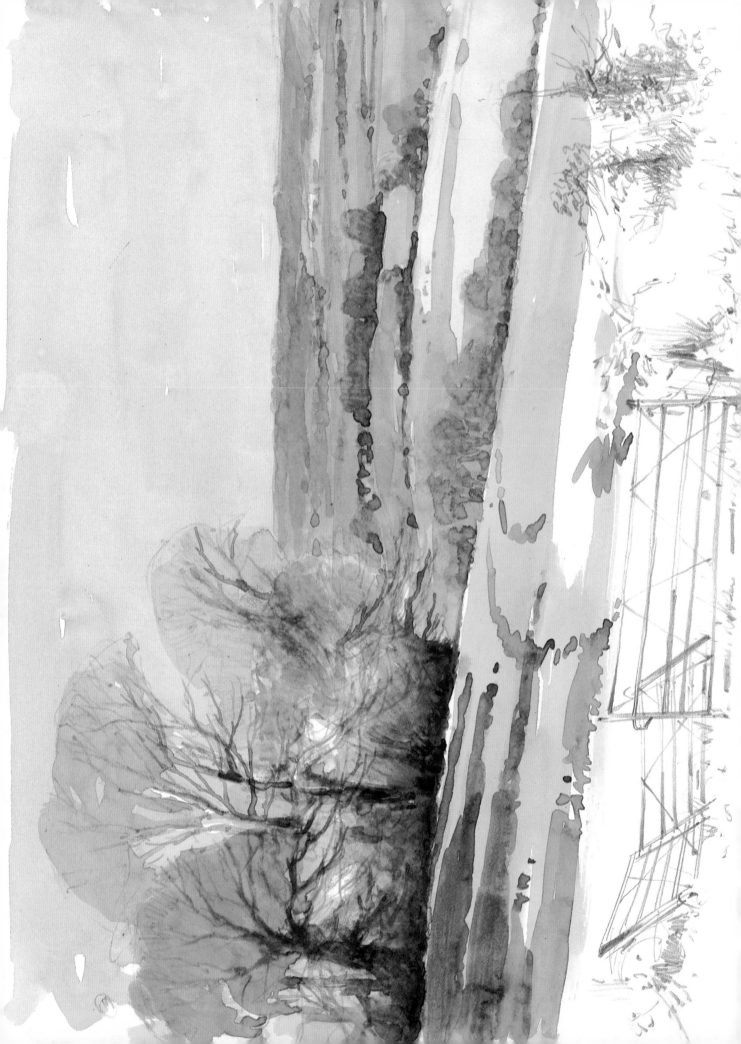

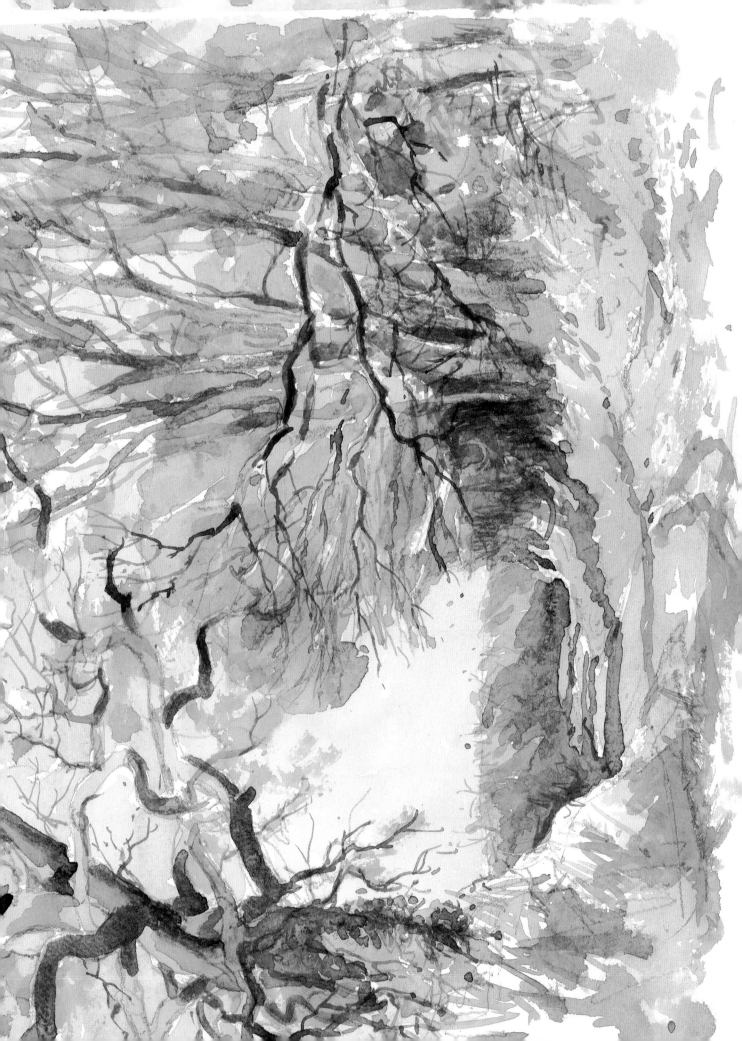

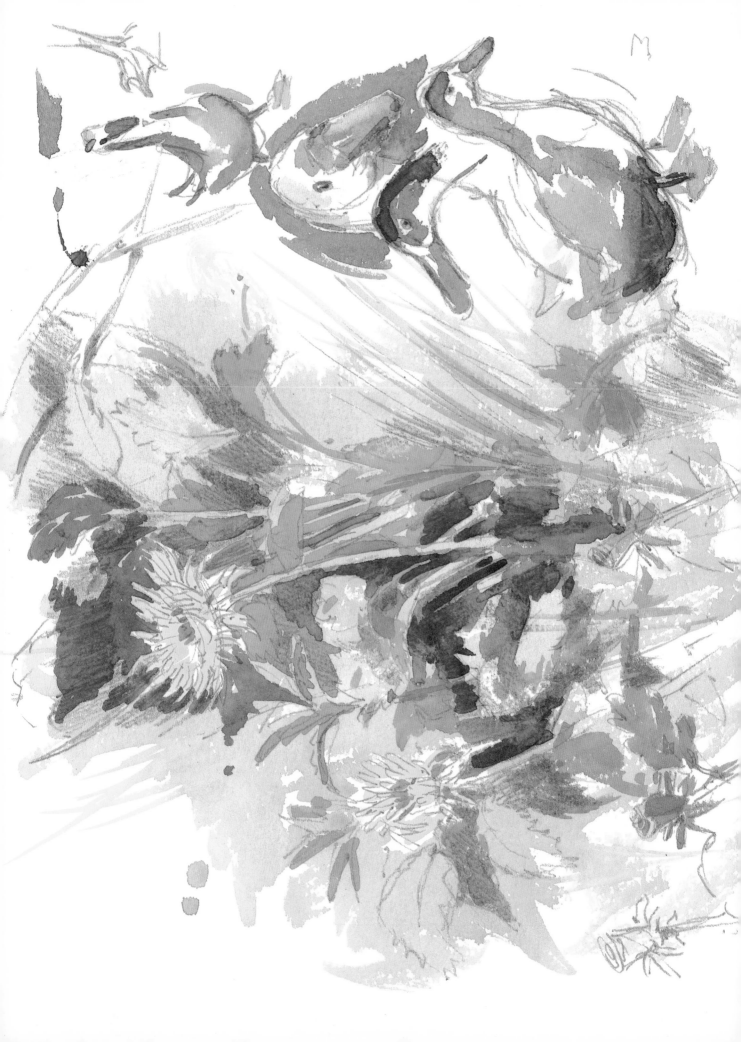

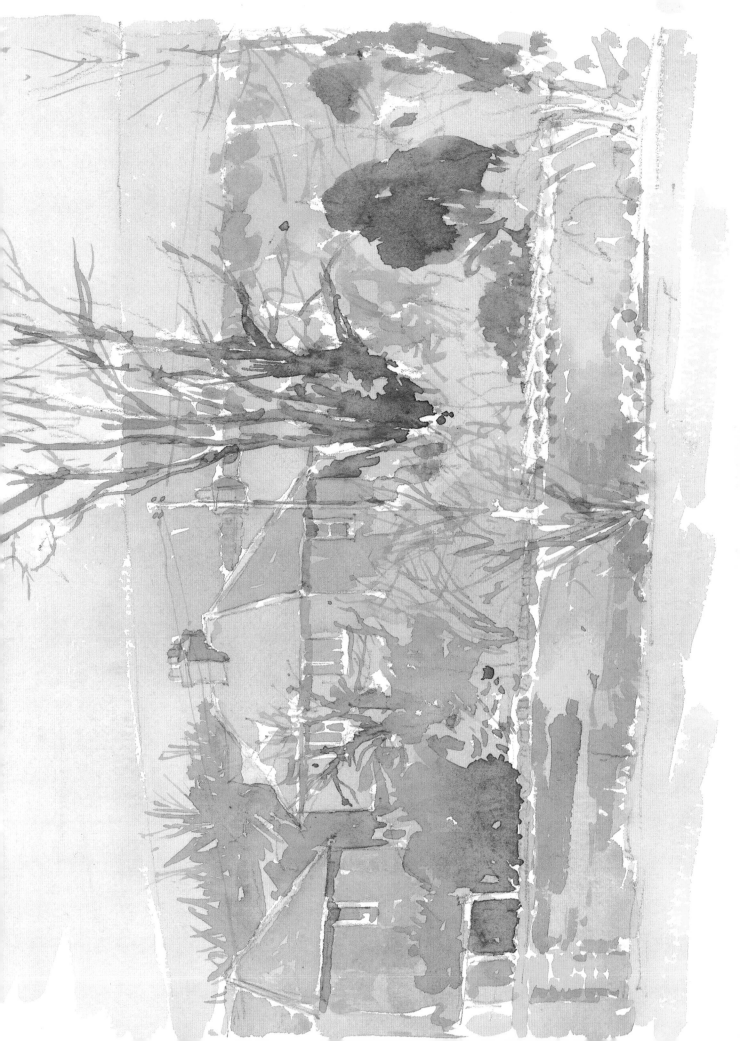

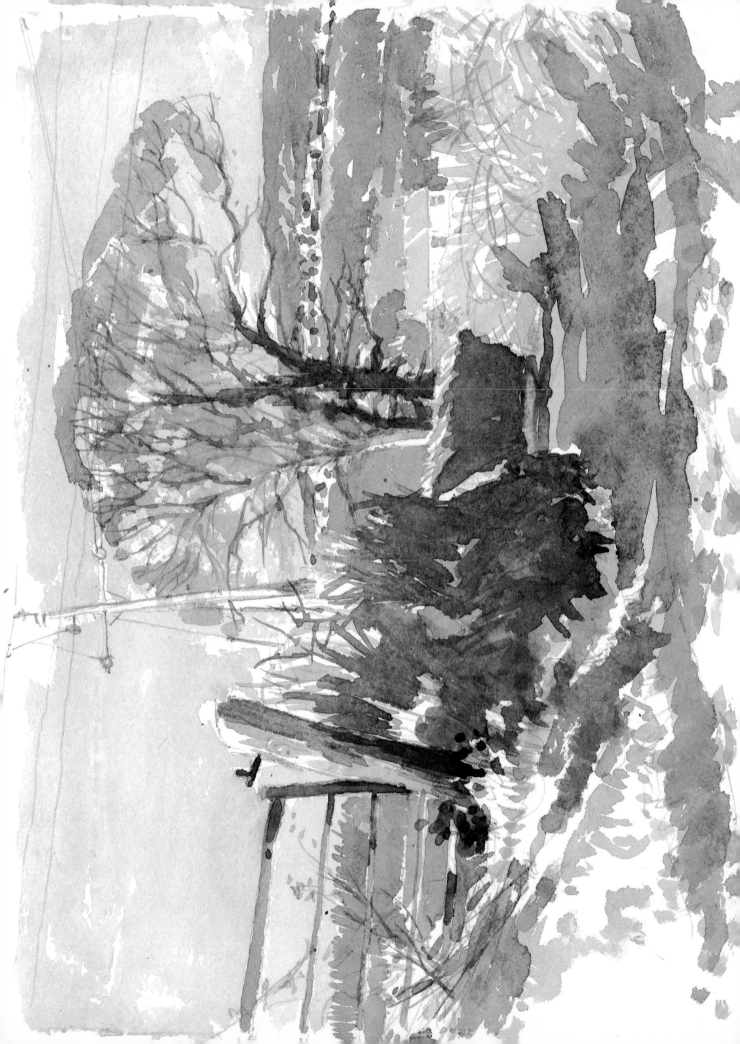

I was demonstrating how to sketch in pencil to a class of students and as I looked round all I could see to sketch were two garden sheds. My audience were not very enthusiastic at first, but we all thought that the finished result was rather pleasing. In fact, it is one of my favourite sketches.

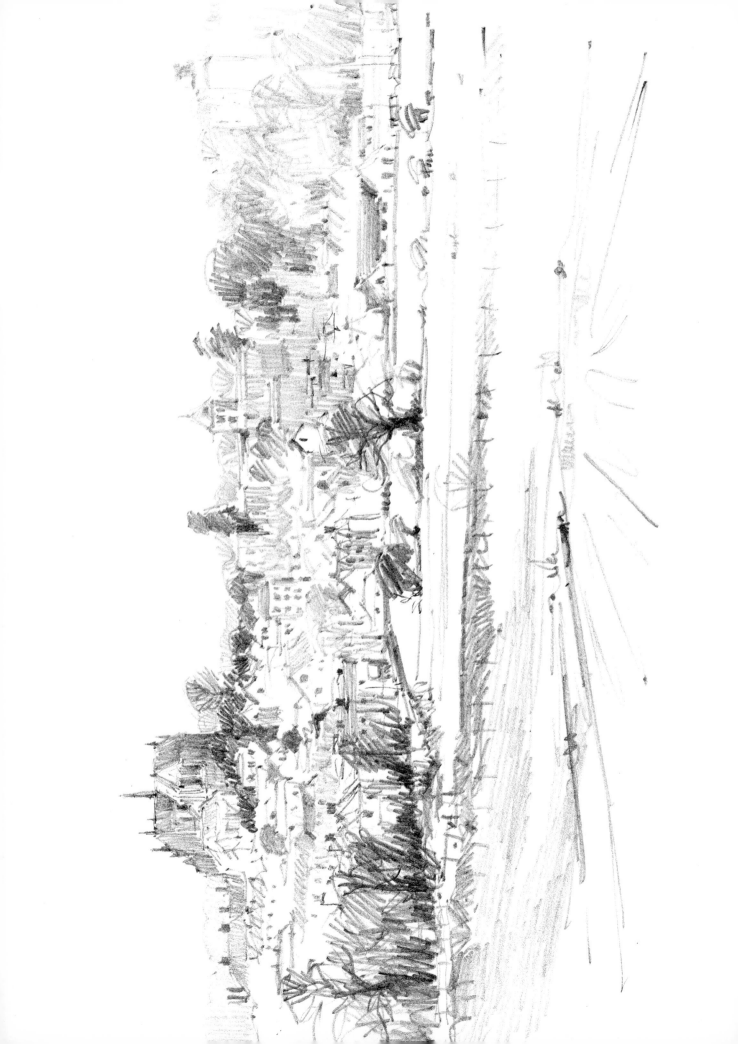

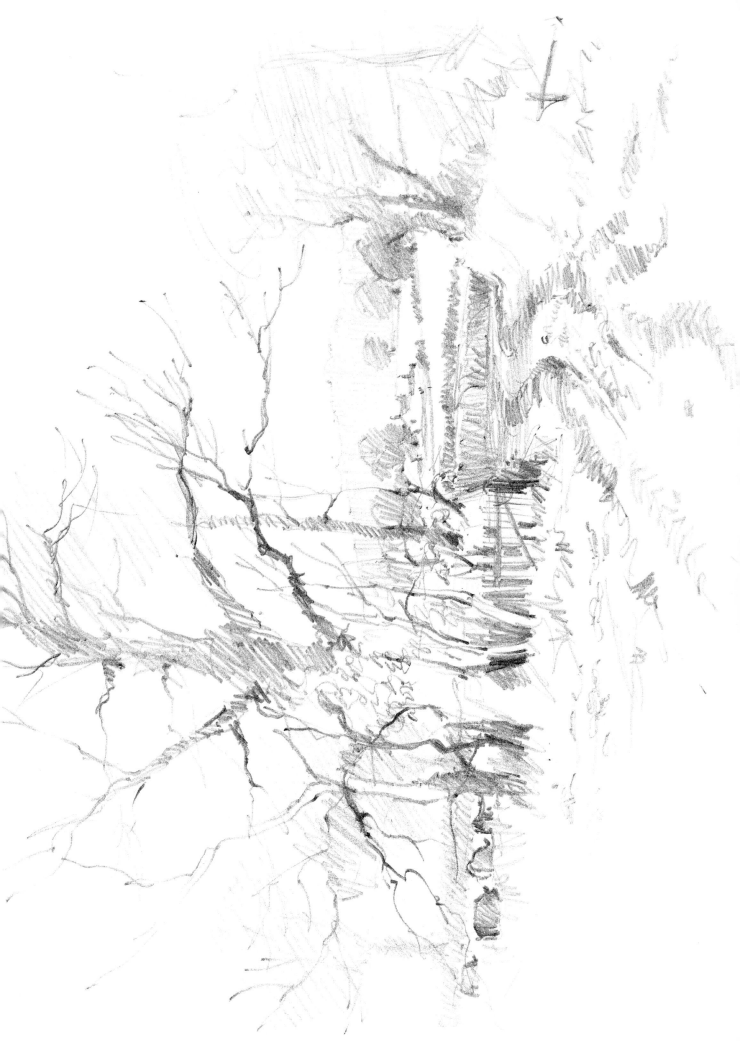

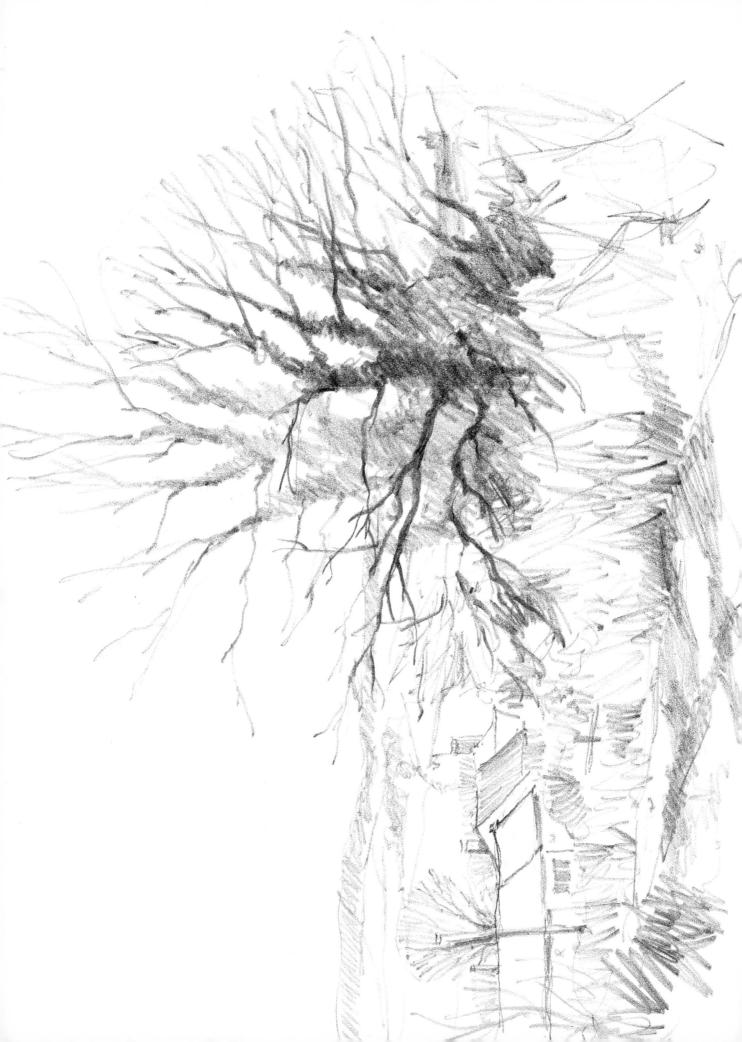

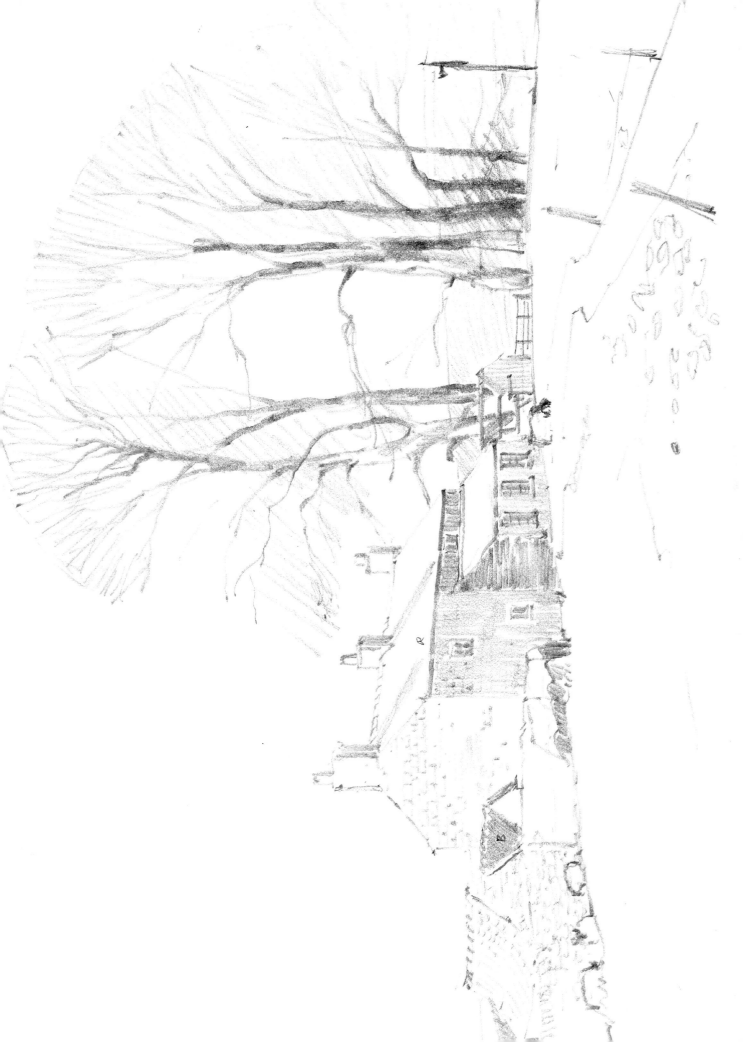

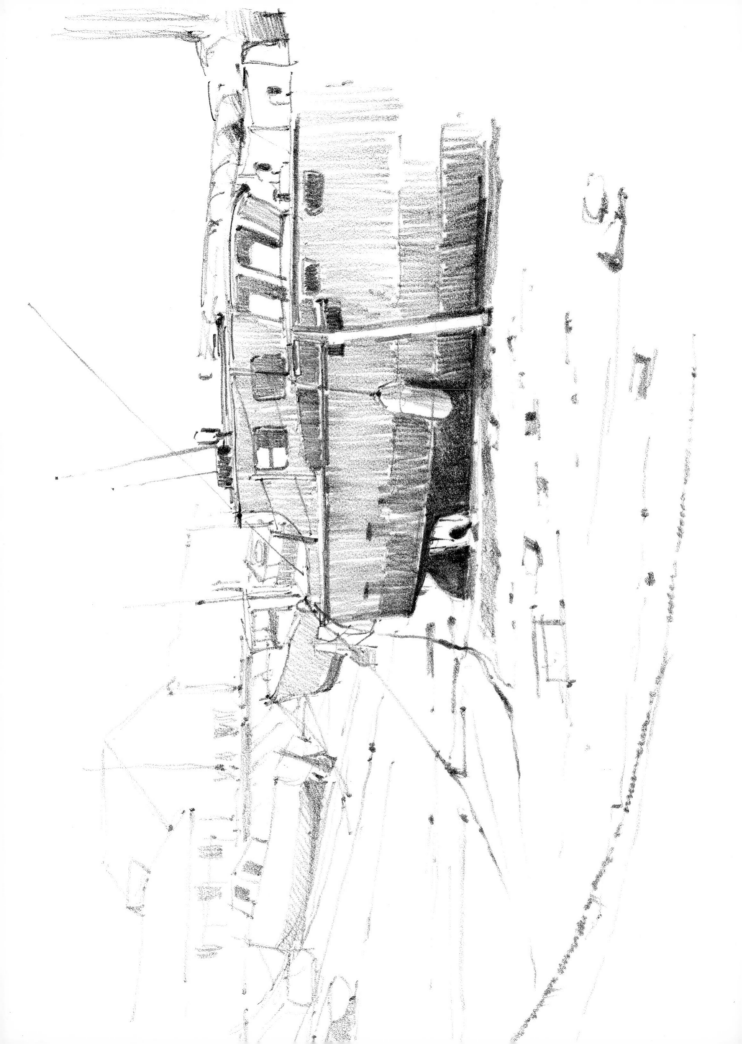

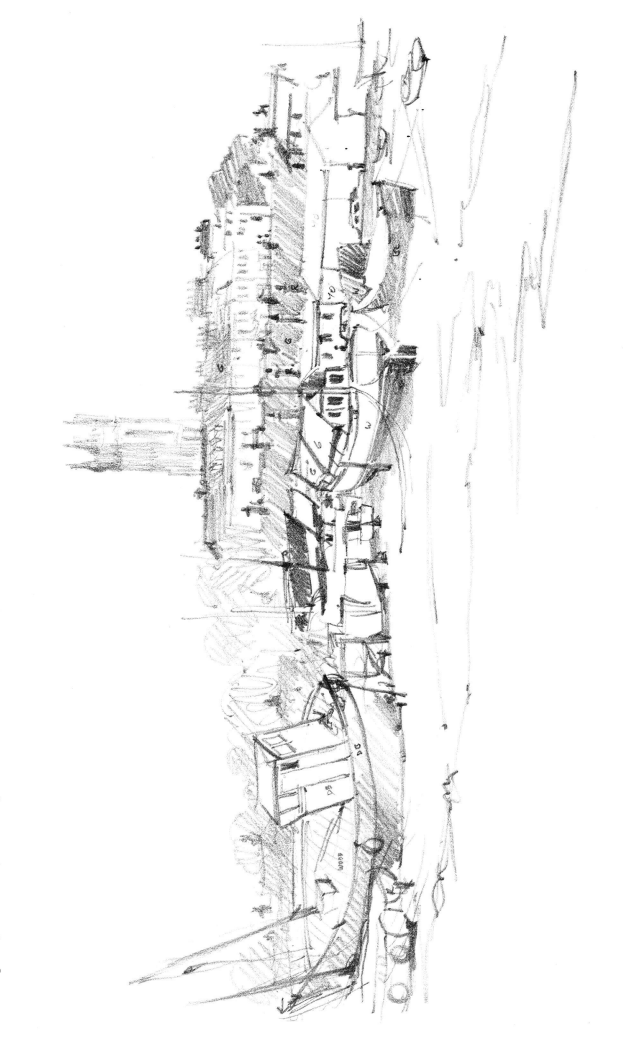

I have enjoyed sketching and painting Exmouth harbour in Devon many times in all mediums: pencil, watercolour, oil and acrylics.

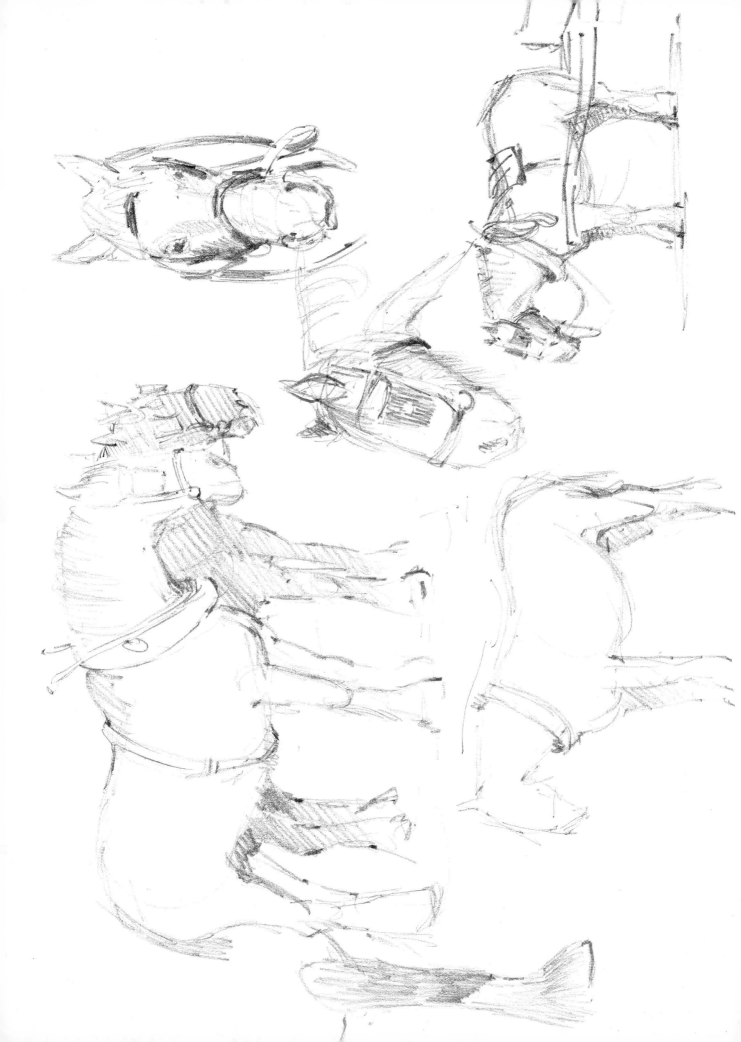

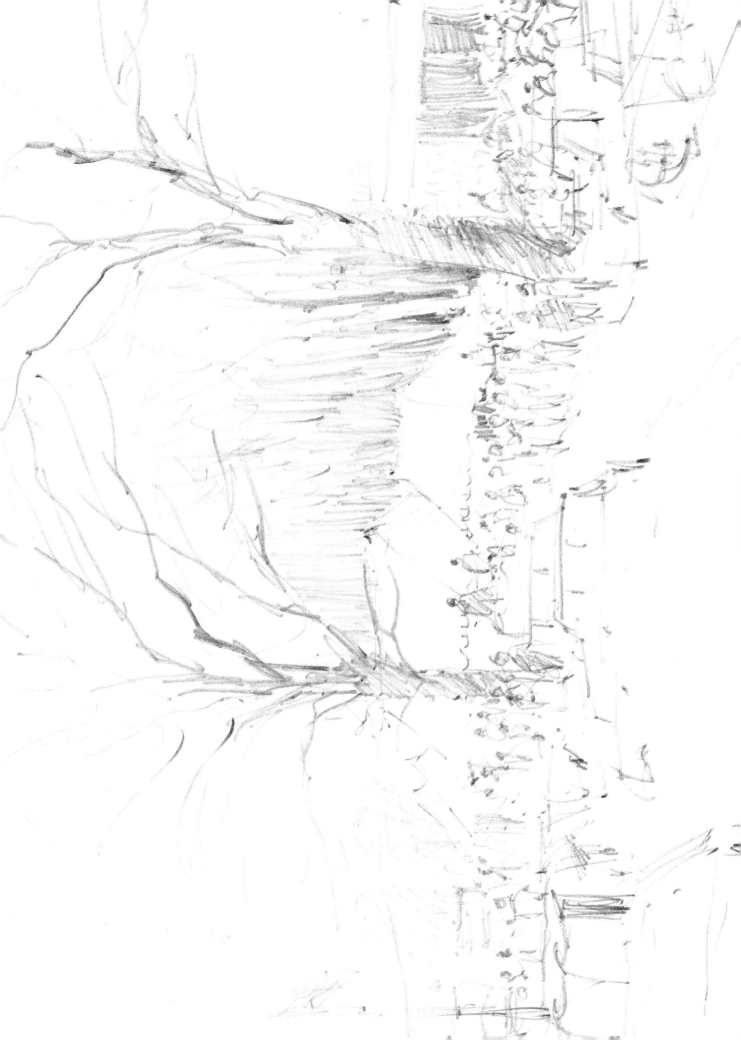

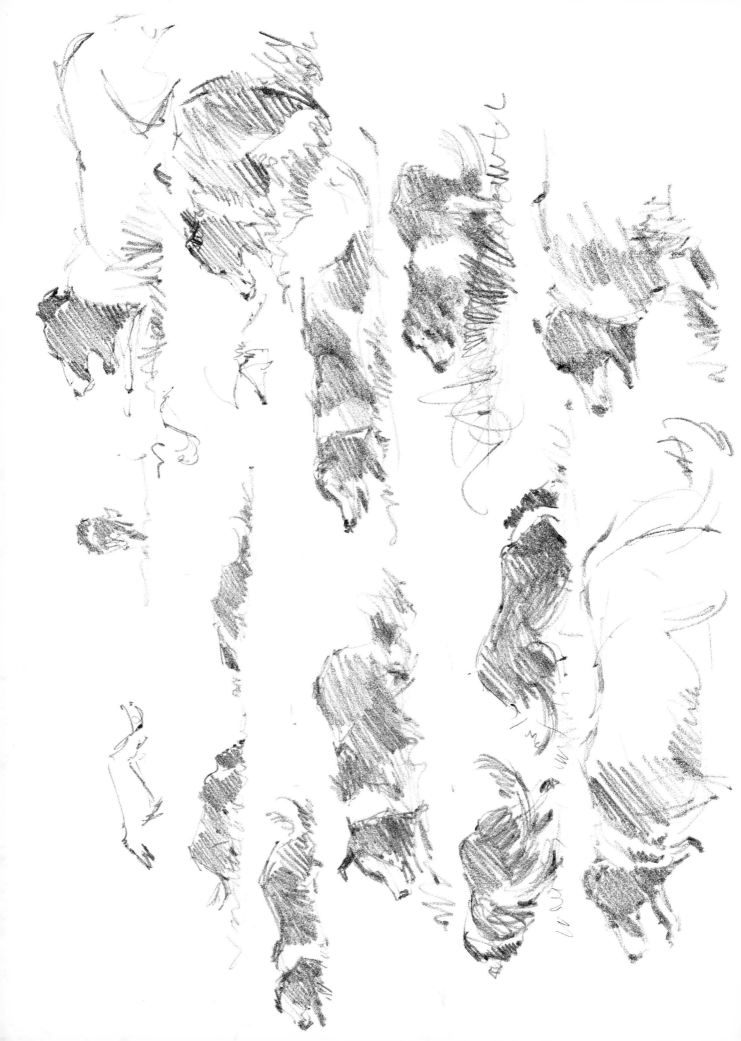

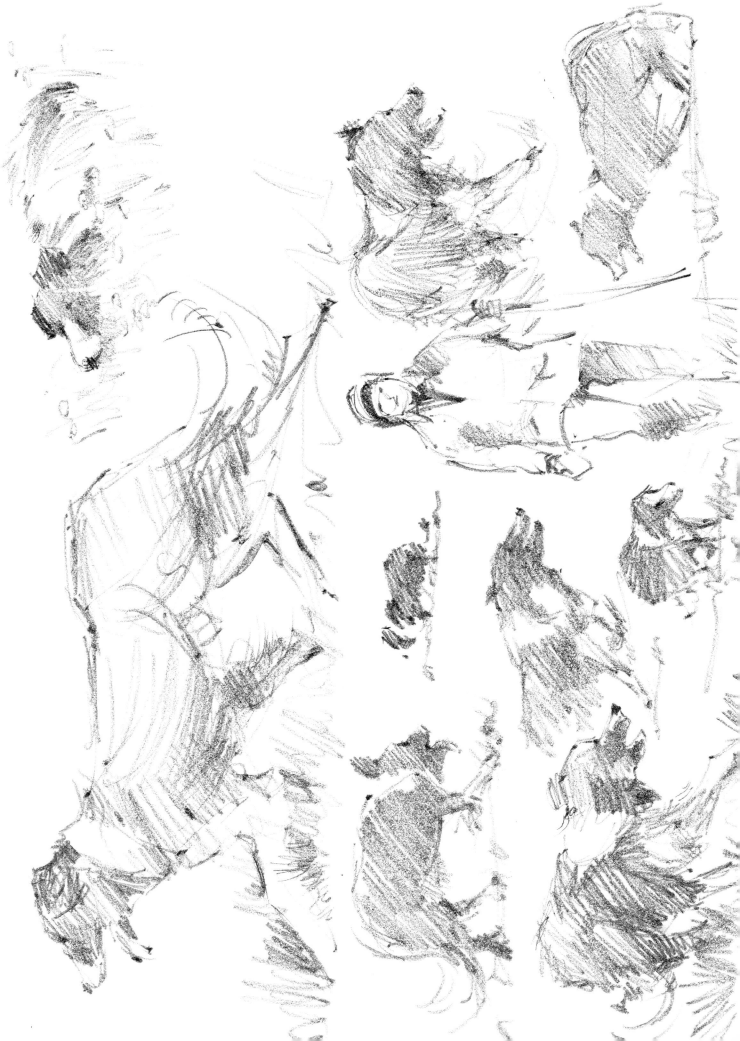

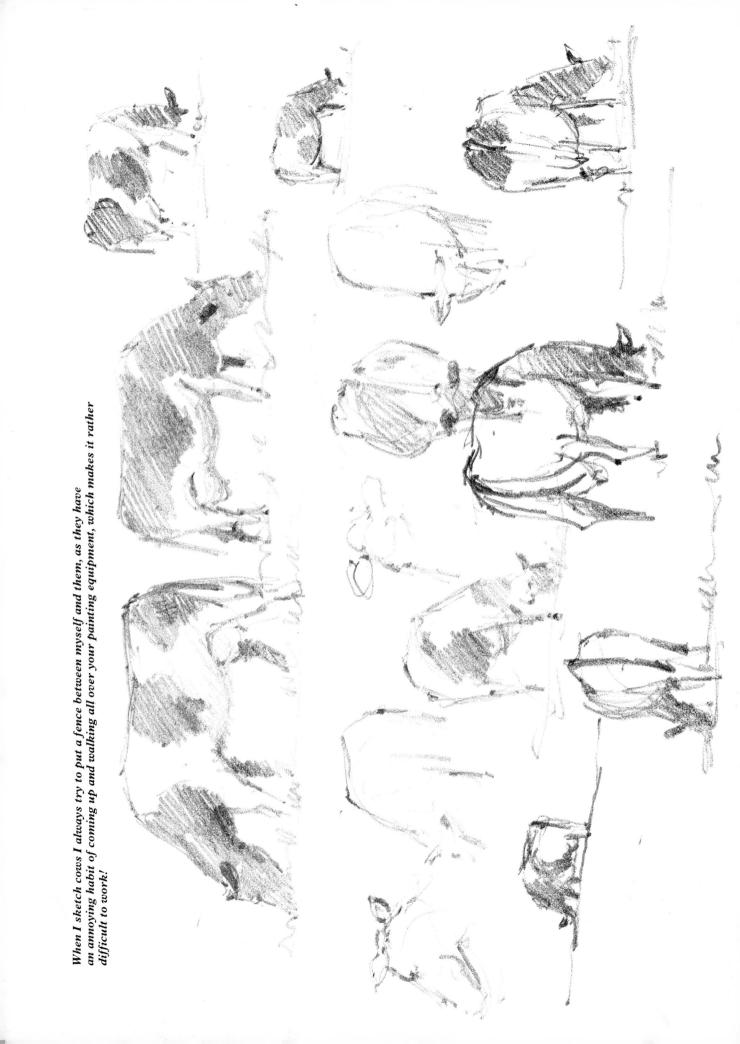

When I sketch cows I always try to put a fence between myself and them, as they have an annoying habit of coming up and walking all over your painting equipment, which makes it rather difficult to work!

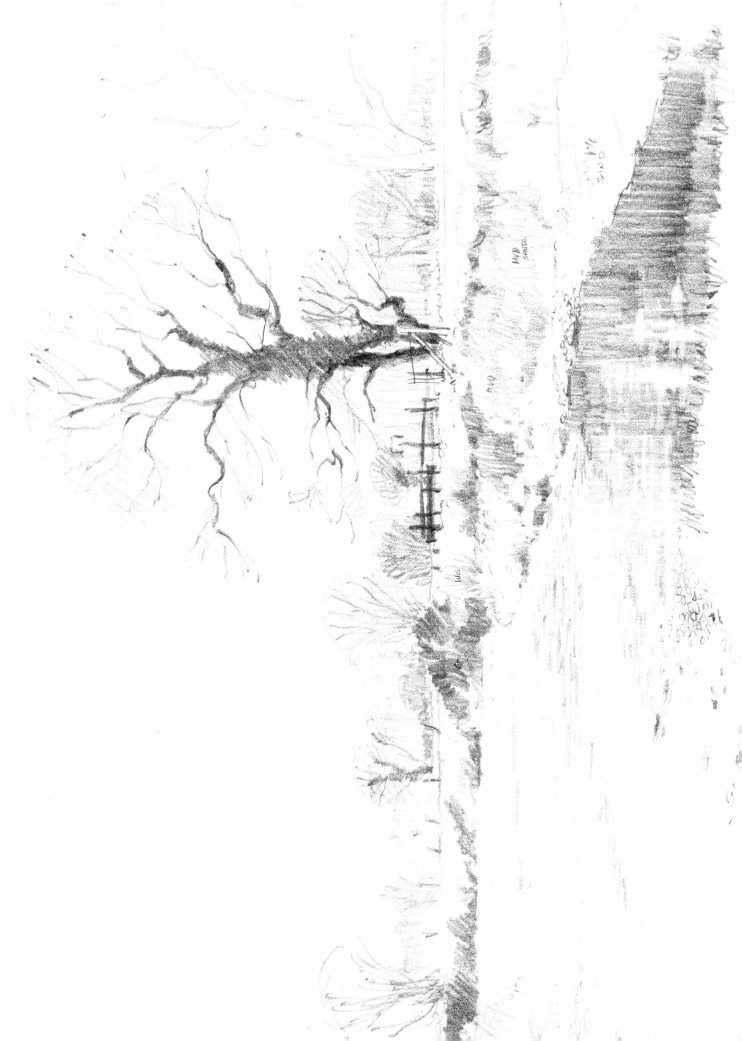

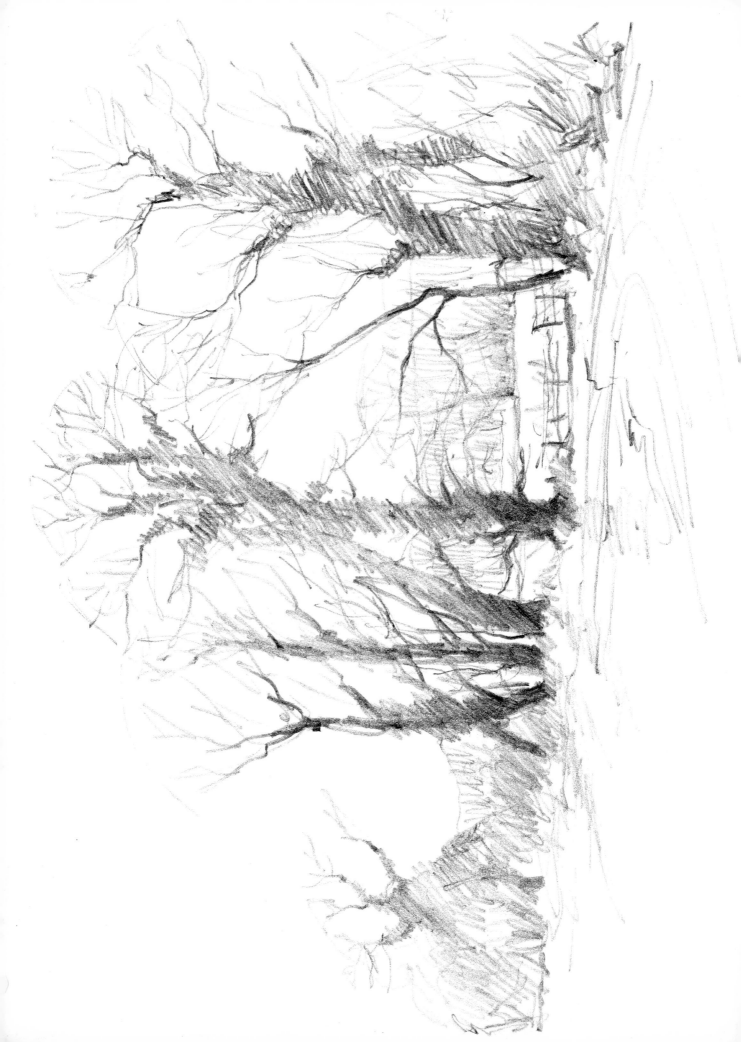

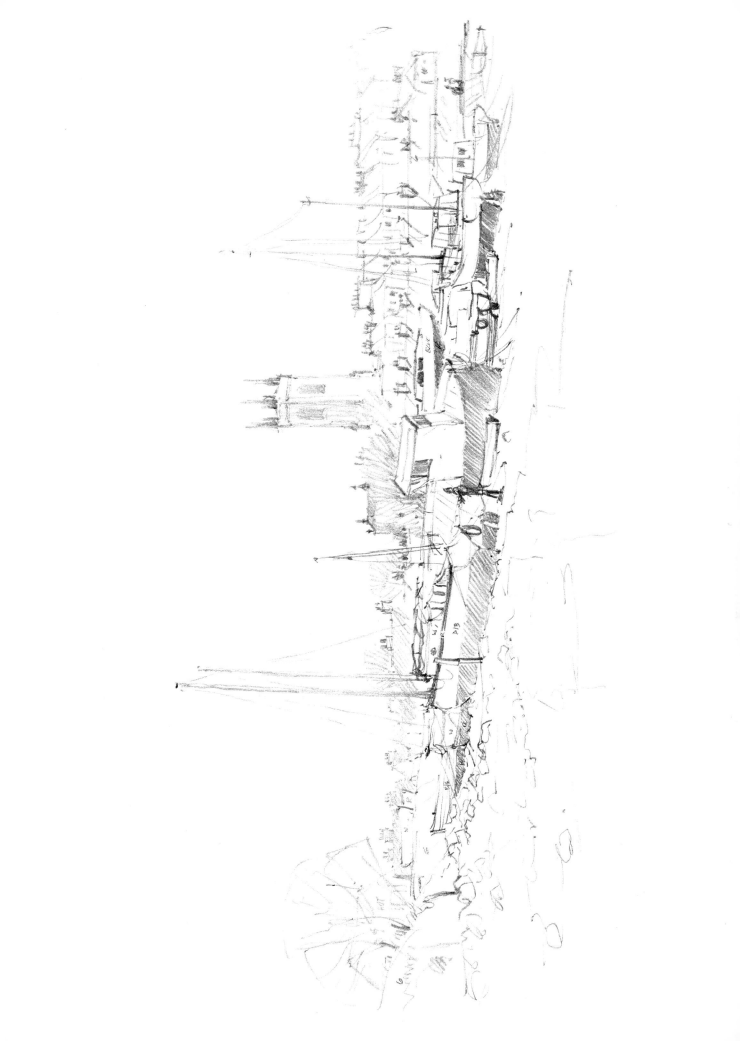

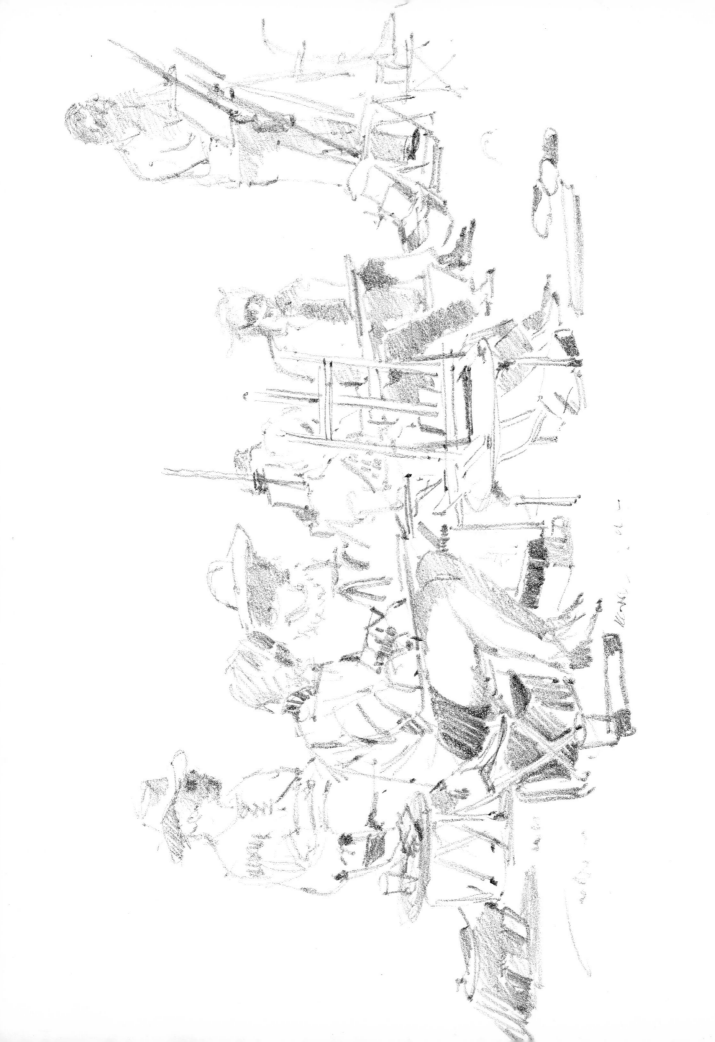